W9-DBK-693

M ALVAREZ BRAVO

238023

M ALVAREZ BRAVO

by Jane Livingston

with an essay by Alex Castro
and documentation by Frances Fralin

DAVID R. GODINE, PUBLISHER
BOSTON, MASSACHUSETTS

&

THE CORCORAN GALLERY OF ART
WASHINGTON, D.C.

COPYRIGHT © 1978 BY THE CORCORAN GALLERY OF ART, WASHINGTON, D.C.
Library of Congress Catalogue Number 78–67204
ISBN 0–87923–266–8 (hardcover)
ISBN 0–87923–267–6 (softcover)

TABLE OF CONTENTS

ACKNOWLEDGEMENTS

This book and the exhibition upon which it is based are the results of three and a half years' intermittent work on the part of many people. Assistant Curator Frances Fralin prepared the chronology and bibliographic material and co-organized the exhibition. Alex Castro has translated from the Spanish and edited the book.

The following people have contributed in diverse ways to this project: Don Albright, Sandy Berler, Malu Block, Rosa Maria Casas, Lee Friedlander, Ann Haas, Francis Harper, Jain Kelly, Sally Opstein, Leland Rice, John Szarkowski, Bernie Williams, and Burton Wolf. Virginia Delfico and Rebecca Zurier have worked closely with me and Frances Fralin in the development of the basic research. Gerd and Christine Sander have prepared the photographs for exhibition; Marti Mayo has coordinated the exhibition tour. For assistance in documentation and production of the book, I want to acknowledge the research, editing, and design participation of Colette Alvarez Bravo, Glenn Hogan, Pamela Lawson, Nancy Martin, Peter Marzio, Edward J. Nygren, Caroline Orser, Sheena Parkinson, John Peckham, and René Verdugo. For lending work to the exhibition, we thank Manuel Alvarez Bravo, the Chicago Art Institute, Raymond Merritt, New York, the San Francisco Art Institute, and the Witkin Gallery, New York. The interview with Manuel Alvarez Bravo appearing in the biographical notes is excerpted from the forthcoming book, *Dialogue with Photography,* by Thomas Cooper and Paul Hill, to be published by Farrar, Straus & Giroux, Inc.

The following museums are participants in the exhibition tour: the Center for Inter-American Relations, New York City; the Tucson Museum of Art, Tucson, Arizona; and the Toledo Museum of Art, Toledo, Ohio.

This event is presented in conjunction with *Mexico Today*, a national symposium of exhibitions, seminars, films, performing arts, and courses on contemporary Mexico, made possible by grants from the National Endowment for the Humanities and the National Endowment for the Arts, and is sponsored by Meridian House International, the Smithsonian Resident Associate Program, and the Center for Inter-American Relations. *Mexico Today* is organized in cooperation with the Government of Mexico.

J. L.

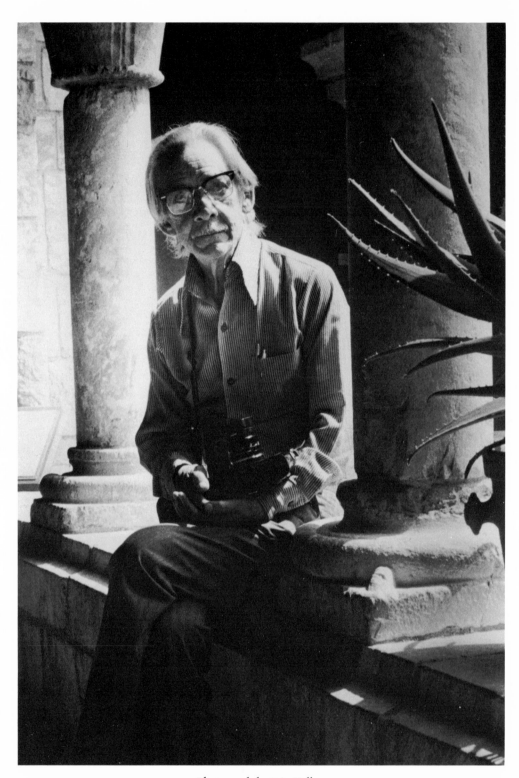

Photograph by Jain Kelly.

MANUEL ALVAREZ BRAVO occupies a singular place in the culture of Mexico, as he does in the history of photography. He is a product of the consciously popular revolutionary movement associated with his friends José Clemente Orozco, David Alfaro Siqueiros, and Diego Rivera (his masters, he says, though "not through their works but through their ideas"); he has roots in both the visual and literary arts which have developed prodigally in Mexico throughout the century. Nevertheless, Manuel Alvarez Bravo is not a political individual. At a time when being an artist in Mexico was bound up with a political objective—culture *was* the revolution—Alvarez Bravo maintained a certain detachment, an attitude evident to this day. He has managed to continue in the spirit of commitment to the cause of enlightened humanism without entering into the concomitant revolutionary dialectic, political or aesthetic, and it is perhaps in part this tenacious independence which, although contributing to his greatness, makes him far less internationally known than would ordinarily be true of an artist of his stature. For he is Mexico's greatest photographer, and indeed one of the most important Mexican artists of our time.

Alvarez Bravo has spent his life in Mexico, with only brief intervals in Europe and North America. The biographical details of his seventy-six-year history in or near Mexico City are treated at length in the chronology, so the intention here is to examine the work itself, placing it within the Mexican ethos and within the context of the history of photography.

Alvarez has developed autonomously. Nevertheless, there are formative ties to the photographers Paul Strand, Edward Weston, Tina Modotti, and Henri Cartier-Bresson. Alvarez knew Tina Modotti from 1926 until she left Mexico in 1930. Though he never met Weston, the Californian's intermittent presence in Mexico

City in the 1920s and 30s surely was felt by the young Mexican photographer. Weston saw Alvarez Bravo's work through Modotti.[1] Alvarez' relationships with Cartier-Bresson, with whom he showed photographs in New York and Mexico City in the 1930s, and especially with Paul Strand, were significant; Strand was a close friend and a source of inspiration, as much in terms of his personal values as of his work.

But before any of these sensibilities were available to him, Alvarez Bravo was looking at book reproductions and works on paper, particularly the prints of the incomparable Mexican satirist, José Guadalupe Posada. At the time of Alvarez Bravo's youth, Posada was widely known in Mexico; he was not only a fine artist but an illustrator whose work was distributed on a fairly broad scale, through newspapers and journals. His illustrations comment sharply on the corrupt leadership of the various Mexican rightist regimes, but more than this, they comment on the vanity, cruelty, and greed of men in general. Posada's impact on Alvarez, at an early stage and continuously throughout his career, cannot be overemphasized. The printmaker's exceedingly violent and active imagery did not manifest itself directly in Alvarez Bravo's work; it is more his complexity of thought, his clarity of expression, and his compositional structure, tending to frontality and flatness, which Manuel Alvarez Bravo has assimilated. Alvarez Bravo is distinctly more static and circumspect in his expression than either Posada or the other artists—Orozco and Rufino Tamayo especially—whom Posada influenced. Unlike the painters, Alvarez responded to Posada's little acknowledged but nonetheless discernable ambiguities and semantic shadings—Posada may have been brutal in his imagery, but he was rarely simple-minded; Alvarez grasped the ambivalent quality of these seminal illustrations to an extent others did not.

In 1922, at the age of twenty, Alvarez Bravo came into possession of two books which, he says, affected him immediately and in ways which can be traced in his own work.[2] One was Maurice Raynal's *Picasso* (Paris, Editions G. Cres & Cie), the other Louis Aubert's *Les Maîtres de L'éstampe Japonaise* (Paris, Librairie Armand Colin). Each has black-and-white reproductions. Alvarez says the former encouraged him to experiment in his photography with cubistic, abstract compositions, *pls. 12 & 13* as in the *Paper game* photographs, which use folded paper for subject matter. This early interest in the modern stylistic modes derived from Europe, so much a part of the vanguard cultural atmosphere of Mexico City at the time, was for Alvarez quite short-lived. Though this interest produced some good photographs, his concern with self-conscious formalism was not to develop. Of the Japanese printmakers, *pls. 8 & 9* it was particularly Hokusai who engaged his imagination. Both *Sand and branches* and *Rock covered with lichen* were directly influenced by the Japanese artist.[3]

x

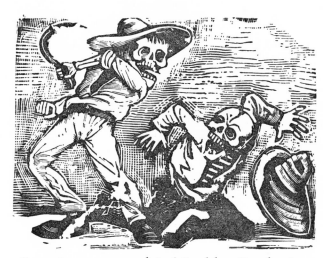

Engraving on typemetal, José Guadalupe Posada, 1894.

Alvarez Bravo characterizes the period from 1922 to 1930 not only as a time of experimentation, but also as one of some bewilderment. Later, in the 1940s, he destroyed a great number of his early photographs. Among the relatively early photographs he has kept and valued are some of those taken with Tina Modotti's view camera which she gave him when she left Mexico in 1930. This first use of a large-format camera, as much as Modotti's own strongly reductive style, seems to have reinforced Alvarez' tendency to simplify and narrow his field of view. However, the radically minimal approach characteristic of his work at this moment (exemplified in *The little deer*, actually taken with Modotti's camera) was to be only one of several later modes of pictorial framing.

pl. 19

As for the early influences of other photographers, Alvarez Bravo mentions an intense, if brief, fascination with pictorialism in all its seductiveness. He knew and assimilated the work of Stieglitz and of Steichen, and slightly later that of Ansel Adams, Kertesz, Sander, and Walker Evans. But it is the association with Mexican painters and writers that seems to have been more nourishing than any particular discourse with other photographers.

The atmosphere of Mexican revolutionary idealism as it existed in the 1920s and 1930s, the hope for creating a forceful communication of demotic values through art which was so prevalent among a large group of artists and intellectuals at this time, had its effect on Alvarez Bravo. His work has never assumed the look nor adopted the iconographies of socialist realism identified particularly with Orozco and Rivera, and the familiar broadness, that rich literalness of expression, both formal and narrative, which the Mexican muralists embody, is completely lacking in his style. Nevertheless, throughout the work, one senses the same fundamental

alliance with the proletariat, through a sustained attention to the existence of the ordinary people of Mexico, that the revolutionary artists were at such pains to establish.

We have more than photographic evidence that Alvarez has been fully dedicated, in a steady, life-long pursuit, to the priorities of the original social realist artists: he is generally reticent in discussing his political proclivities, but in 1966 he said in a rather unusually programmatic statement, ". . . a popular painter is an artisan who, as in the Middle Ages, remains anonymous. His work needs no advertisement, as it is done for the people around him. The more pretentious artist craves to become famous, and it is characteristic of his work that it is bought for the name rather than for the work . . . a name that is built up by propaganda. Before the Conquest all art was of the people, and popular art has never ceased to exist in Mexico. The art called Popular is quite fugitive in character, with less of the impersonal and intellectual characteristics of the schools. It is the work of talent nourished by personal experience and by that of the community—rather than being taken from the experiences of painters in other times and other cultures, which forms the intellectual chain of non-popular art."[4]

The stylistic development of Alvarez Bravo's work over time is an immensely complex one. In subject matter, technique, spatial handling, and composition the work demonstrates numerous shifts and departures. He is a master of his medium, having used it in many capacities for decades. He has printed from one negative in numerous techniques, including, recently, palladium. He has experimented with commercial color-printing processes as well as with dye transfer. He sometimes employs assistants to print for him, but never without his overseeing presence. But often as not, Alvarez Bravo, in contradistinction to most of his peers, is relatively unconcerned with the quality of the prints themselves. To this extent, notwithstanding his elaborately equipped darkroom, he is not primarily a craftsman but a composer, who, like many great composers, seems to let composition dictate itself.

Although the oeuvre is strikingly various in its overall construction, some distinguishable patterns and themes run through. We might divide it into the following groups: the early abstract compositions; the "open" landscapes; the dense, or "closed," landscapes; the specifically composed "art and nature" images; anonymous people in ordinary activity; the walls and windows; the portraits; and the overtly symbolic or metaphoric works which fall into several sub-types. Finally there is the matter of the color photographs.

Throughout his career, Alvarez has made occasional photographs of small objects
pls. 19 & 53 in half-clumsy arrangements, and a few of these—especially *The little deer* and *Wooden horse*—are powerfully effective for reasons that are fundamentally beyond

analysis. The poignance of these presentations of homely things, whether banal folk icons or details of plant life in his own garden, is somehow never trite. That he so rarely makes close-up, purely formal works of this kind may add to their specialness and appealing anomalousness. At the opposite extreme from these intimate compositions are the expansive landscapes, such as the many views of Lake Texcoco (not reproduced). These wide, aerated landscapes are initially obdurate, or uningratiating; but with time, they embed themselves in one's consciousness and become among the most haunting and profound of all his works. In this connection *Chamula landscape with two groups* and *Kiln number three* enjoy a special status. The first is a *pls. 1 & 37* formidably complex work with many implications. It holds the suggestion of a pilgrimage, as well as a statement about man in his connection to nature; it is a pungently Mexican landscape with reminiscence of both the art and landscape of the Orient.

A very different approach to landscape is seen in *Cactus landscape* or *Landscape of* *pls. 14 & 15* *sown fields*: here the abstract rhythms of the earth, cultivated or raw, create what might be empty formal exercises but are somehow transformed into intensely lyrical, even musical images. (Alvarez is in fact something of an expert in the area of music, having discriminating tastes and a sophisticated understanding of interpretive nuance, especially with respect to Bach and the Italian Baroque.) The natural and the artificial are often pointedly juxtaposed in his photographs, sometimes in a spirit of irony, sometimes merely in play. *Landscape and gallop, Twilight bird swayed* *pls. 27, 60,* *by the wind*, and *Huichol violin* are examples of works in which the man-made and *& 80* the natural are synthesized, becoming a single thing. An equation is drawn between the fabricated and the found. This unity extends into the fundamental sensibility of the photographs characterized as "anonymous people in ordinary activity." The classic examples in this category are the views of figures walking in front of a wall, such as *How small the world is* or *La María*. And sometimes there is simply a wall, *pls. 2 & 26* with perhaps handprints or graffiti, though often a figure or animal appears in front. Mexico, of course, notably presents to the passerby walls rather than gardens or fences, and one suddenly begins to view this as potentially significant in terms of the ethos of the people. Alvarez Bravo's walls are hieroglyphs and maps and man-made landscapes; they aren't barriers. The walls for him become the plane in relation to which action is particularized.

In his depictions of laboring figures he often establishes an equation, or symbiosis, between actor and object. Alvarez Bravo's anonymous subjects are often a type belonging not to the pure Spanish group, nor to the Mestizo, but to the Indian and, accordingly, his aesthetic refers to pre-Columbian native archetypes. This preoccupation recalls again the synthesis he achieves of a thoroughly European modernist

xiii

understanding of form, with the ancient, essentially unselfconscious approach to representation which is integral to his heritage. In the portraits, a classical and sophisticated mode prevails. In them he comes nearer to the conventions of European and North American art photography than he does through any other aspect of the work. The portraits are direct and accurate and exceedingly incisive.

pls. 28, 29, & 31

Alvarez Bravo seems to adopt two strikingly different attitudes in relation to his use of allusive images: on the one hand, he is quite capable of making straightforward, obvious statements about the presence of death in our daily world merely by presenting death's physical traces, as he does in the photographs of graves or bones. In a photograph such as *Burial in Metepec*, one senses no irony or layered meanings—but the image is certainly more than simply a documentary exercise. It is a metaphysical statement, an image presenting a special reality whose nature requires transcendence to accept. But more often Alvarez Bravo's use of symbolism is complex and ambiguous, as in *Ladder of ladders*, *Optic parable*, or *Angel of the quake*.

pl. 3

pls. 11, 25, & 52
pl. 45

Alvarez sometimes uses human subjects themselves to represent ideas or abstractions—the primary example, of course, is the famous *Striking worker murdered*. But his subjects are usually observed in a more mundane way; the psychology of a given figure is likely to be conveyed through its relation to surrounding objects or through unforced gestural nuances, not through the camera's direct search for or confrontation with face or body. His subjects consistently project dignity and contained privacy; when a comic note enters into the photographs, it is never at anyone's expense.

His compassionate treatment of people as subject is not romanticized, or heroicized, as for example occurs in Paul Strand's Mexican photographs; Alvarez maintains a consistently nonrhetorical approach to compositional framing and to events themselves. He often brings our attention to peripheral, or sub-dramatic, moments or transactions or places. It is so often as though the photograph had virtually composed itself; Alvarez tends not to monumentalize people or objects as dramatically as do both Strand and Weston, nor does he often play with deceptive or illusionistic spatial juxtaposition. (He occasionally, in the late 1960s and 1970s, uses a wide-angle lens or double exposure; but this is as far as he goes towards artificial manipulation.) In fact, space is rarely perceived in his photographs as a deep pocket; nor is the inherent evocative potential of articulated sky detail (cloud formations and variegated light patterns) used to establish mood or atmosphere. Instead, he uses strong light and shadow, as a painter at times employs chiaroscuro to create atmospheric modeling. But if space in Alvarez' work seems somehow laterally extensive rather than recessive, it is not a cramped or constricted sense we get.

So much is his sense of space natural and undistorting that we scarcely think

about such notions as framing stance or camera angle. Yet we do think about juxtaposition. One of the ascendant mysteries, or problems, of Alvarez' photographs is a distinct paradox applicable to much of his work; the photographs are simple and clear, sometimes to the point of reductivism, and yet they are undeniably complex works of art. With the possible exception of some of the early abstract photographs, there are at least two, more often several, coexisting levels of meaning in the photographs. This reveals the constant presence of thought, or intellection, more than any contrived aesthetic devices or techniques. The artist views his subject with a refined sense of multiple possibilities. And he projects the very process of his conscious choices as much through what is absent as through what is found.

It is unusual for the artist to attach to the photographs neutral descriptive titles. The titles are literary, often poetic, and are integral to the reading of the images. It is parenthetically worth noting that the titles are often difficult to translate into English: they are sometimes half-idiomatic or punning, and even when yielding to translation, they often have multiple connotations.

A crucial aspect of Alvarez Bravo's aesthetic development, and one which has been almost ignored, is the influence of his many years spent systematically photographing the works of the Mexican revolutionary muralists as well as other works of art in Mexico, including Colonial paintings and folk art. Of necessity, in documenting some of the vast ceiling murals of Orozco, for instance, the photographer must have an instinct for proper framing of details, and thus must inevitably become attuned to abstract composition and to pattern. Alvarez Bravo has doubtless spent more hours in the service of other artists than in his own artistic endeavor. In fact, the two most prolonged phases of his professional life have involved intense production whose nature is slightly removed from the activity of making the photographs for which he is best known.

During the years 1943–1959, spent as a photographer and cameraman at the Sindicato de Trabajadores de la Producción Cinematográfica de México, his own work seems to have taken second priority. In this role, as in others, Alvarez Bravo worked unassumingly at peripheral jobs. Yet we may gather that much in Sergei Eisenstein's *Que Viva México*, for example, and perhaps also in Buñuel's *Nazarene*, shows the influence if not the actual work of Alvarez' eye. It is worth noting that he also worked closely with the Mexican director José Nevrieltus, and with the American John Ford. As well, in 1934, he made a film of his own, *Tehuantepec*. It is startling to observe that the built-in stylistic exigencies of the cinematic medium, particularly as to framing still images for use in scenario planning and even for site hunting, do not greatly extend to Alvarez Bravo's other work. The cinematic demand for rhetoric, intelligible narrative, and dynamically framed shots is alien to Alvarez Bravo's way with the camera.

Similarly, during his years spent producing the elegant and superbly legible volumes of color photographs of Mexican art for the Foundation for the Plastic Arts (1959 to the present), Alvarez Bravo has scrupulously separated his activity as artist from that as documentarian. In his own important work he has never allowed himself the luxury of effulgent expression that he does in the documentary re-creations. Here it is appropriate to consider the issue of his own color photographs, which are not central to the production as an artist, but are, nonetheless, interesting and successful. This question of color becomes exceedingly complex in light of his work for the lavish Foundation volumes. There is a curious difference in tone, sensibility, palette, and texture apparent between the color photographs made for the Foundation books and his own occasional color photographs, whether the early dye-transfers (the first was made in 1938) or the later processed color prints. In contrast to the Foundation productions, his own work eschews broad, complex, or lavish chromaticism, favoring near-monochromaticism and even the kind of murky, subdued palette noticeable in the early color photographs. These works are unsettling; they are subtle in a different way than are his black-and-white photographs—color itself becomes a kind of psychological quotient in our reading of the images. Partly owing to the relatively primitive state of the technique of the dye-transfer process when Alvarez Bravo first used it in the late 1930s, the early color photographs are peculiarly opaque, or dim, in tone and value. It is not that a certain garishness is entirely absent—the colors are even faintly maudlin—but any sense of overt riotousness is definitely avoided. This paradoxic quality persists in the more recent work. The restraint which we sense in the color photographs relates to the generally low-keyed mood of all but a few of the photographs.

The earliest color works show an awareness of Surrealism in both the somewhat eerie palette and in the images depicted—one of the first color works he ever made frames a woman's arm, seemingly disembodied, curved with open palm against a

pl. 76

pl. 75

field of grass and dandelions. And similarly, *In the morning* (showing the same model—his wife—and dress as that in *Unpleasant portrait*) is made in a Surrealist mode. The most recent color photographs generally convey a tentativeness, as though the artist was experimenting with the added dimension of chromaticism in terms of mood or psychological tenor, rather than concerning himself with color

cover plate

in a painterly sense. The truly successful works of this type, such as *Verde*, work in just this atmospheric way, as expressions of some kind of emotional truth rather than as alluring or resonating studies in color.

Recently the artist has begun printing old negatives in a new way, with palladium, on rag paper. This technique gives a delicate surface character to the photographs, a quality not unlike that of photogravure or even some lithography. Palladium print-

xvi

ing of necessity imparts a relative uniformity of value and tonality; absolute blacks and whites are not within the range of the medium, but a high degree of gradient modulation comes into play. These recent photographs have a new aura of individual preciousness. The four examples included here give a sense of the variety of *pls. 19, 74, 75 & 82* kinds of images being printed with this technique, and some sense of their tonality, though of necessity the full impact of their differentness from the earlier work is not evident. The palladium prints seem in some way an acknowledgement of the iconicity of some of the artist's compositions; they are among the most moving of all the work. Rather than the full, fresh, dynamic immediacy felt in a photograph like *Striking worker murdered*, these objects become the expression of a seasoned, *pl. 45* refined, consummately masterful aesthetic sensibility.

Manuel Alvarez Bravo's constitutionally poetic use of visual as well as verbal imagery has its roots in both the ancient and modern art of his national milieu. Poetic images and concrete symbols in Mexican life, as in its art, seem to lodge in universally familiar syntax. The horse, the dog, the pair of hands at work, drapery on clothes lines, the mask, the skull, the serpent—such objects have mythological significance understood by every Latin American. The sources of meaning often are plural, having origin in pre-Columbian and Christian religious imagery as much as in post-Conquest historical episodes. The universality and interpretive flexibility of these signs give them at the same time a power of evocation and a certain neutrality. They can be used, in other words, in ways that transcend obvious didactic intent, to convey a luminous metaphysical essence; and the uninitiated may perceive the gravity, but not always register the *lightness* of tone, the fragile irony or humor, with which seemingly aggressive, even bombastic, images are often intended. Such writers as Octavio Paz, Carlos Fuentes, and Juan Rulfo, and certainly the Argentine Jorge Luis Borges and the Chilean Pablo Neruda, have helped to make clear the complexity of the obsessive visual symbols in the life of Latin American art and culture, using certain images so variously or equivocally that the obvious comes to be mistrusted. But no Mexican visual artist in recent times has so intelligently, so gently and understatedly as Alvarez Bravo employed the full vocabulary of the delicate Mexican sign language in an extended body of work.

Alvarez Bravo is of course entirely aware of the elusive iconologies of his images, but he sometimes plays on their meanings in inscrutable ways. The odd juxtapositions (coffin with gramophone, street signs with animals) may or may not yield to syntactic or mythologic analysis. Alvarez seems reluctant to elaborate on his own intentions in this area: he admits to an underlying concern with the life/death complement, though he does not seem especially obsessed with Catholicism. But he is evidently fascinated by the stimulative power of these recurring themes—he focuses

pl. 41 again and again on the dog, and the heraldic cactus or agave appears repeatedly. The truly mytho-poëic grandeur of *Sheets*, in which the hands of the woman, the drapery, the sweeping rhythm of the whole create a classical work of art, represents a high moment in Alvarez Bravo's assimilation of the symbolic poetic mode.

Alvarez Bravo is absolutely deliberate in his use of folkloric symbols and icons— it is not as though the photographs of grave sites and of Christ effigies, for instance, are in any way arbitrary; they have plain reference to an idea of death or of *vanitas*. And yet, even as we are conscious of the artist's own awareness of the immediacy of some of his especially laden and transparent metaphors, we are made to question slightly any supposed intent to comment. The photographs are acutely modest; they are, finally, astonishingly unaffected. This character of artlessness, this sure-footedness of vision, this combined irreducibility and complexity that ordinarily only occur in our direct perception of nature itself, rarely in its interpretation— these things are at the heart of Manuel Alvarez Bravo's genius.

1 Edward Weston recorded in an entry in his *Daybook* for May 1, 1929:
 "May 1. I have been the recipient of a package of photographs from M. Alvarez Bravo of Mexico, D.F. When I was assessed $2.50 duty, I felt rebellious, but upon opening the package that feeling vanished—I was enthusiastic! Photographs of better than usual technique, and of excellent viewpoint. One of a child urinating, just the little round belly, his 'trimmings' in action, and an enameled dish to catch the stream: very fine! So many were of subject matter I might have chosen, rocks, juguetes, a skull, construction. I wonder if this person, Sr. Sra. or Srita, quien sabe?—does not know my work, or Tina's? In fact I had a suspicion—and still wonder—if these prints are not from Tina—under assumed name,—perhaps to get my unbiased opinion. The inclusion of a delightful petate recuerdo also excites suspicion. And the prints are mounted on the same cover board we used in Mexico. It is all a very nice mystery!"
 Edward Weston, *The Daybooks of Edward Weston*, ed. Nancy Newhall (New York: Horizon Press, 1966), vol. II, p. 119. See also Weston's letter to Manuel Alvarez Bravo, reprinted below, p. xxxiv.
2 Recorded in conversation with the artist, Coyoacán, June 1976.
3 *Ibid.*
4 Statement by Alvarez Bravo from *Painted Walls of Mexico from Prehistoric Times until Today*, text by Emily Edwards, photographs by Manuel Alvarez Bravo, foreword by Jean Charlot (Austin: University of Texas Press, 1966), p. 145.

ALVAREZ BRAVO & MEXICO

> *. . . la fotografía de Manuel Alvarez Bravo es mexicana por causa, forma y contenido, en ella la angustía es omnipresente y la atmósfera está sobresaturada de ironía.*
>
> (. . . the photography of Manuel Alvarez Bravo is Mexican by cause, form, and content, anguish is omnipresent and the atmosphere is supersaturated with irony.)
>
> —Diego Rivera, Catalogue of the
> Third Exposition of the Society
> of Modern Art, Mexico City, 1945

The very nature of the Mexican imagery in the work of Manuel Alvarez Bravo can be an impediment to understanding. The work is rich in interest to the casual viewer in that it is exotic, and the non-Mexican is easily led to an enjoyment of this element alone, the Mexico of the tourist: the scenic, the unusual. But to Alvarez Bravo the richness of Mexico is a quotidian experience, one which he presents simply, monumentalizing the real, not the fictive.

The development of a vocabulary drawn from America rather than from Europe alone was not unique to Alvarez Bravo among Latin American artists though he was the only photographer of note to use it. Mexico at the turn of the century was in a process of revolution and was, therefore, in a position to reappraise its dependence upon Europe in a way that other Latin American countries could not. The realities of the war focused the social and cultural problem within Mexico so strongly that European influence was considerably weakened.

Mariano Azuela (1873–1952) was the first to create an entirely Mexican idiom. *Los de abajo* (The Underdogs), first published in 1915 and virtually unnoticed until it reappeared in installments in Mexico City in 1924, became the guidepost for much of the art which followed. While other writers throughout Latin America were still writing about the Spain of Philip II, the meditations of the devout, the conflict between the romantic hero and his environment, Azuela presented the Revolution through the eyes of those people who saw it most clearly, the peasants, the Indians. His presentation was simple and immediate, his characters, unromanticized. Azuela's effect on the artists who followed him, visual and literary, was profound.

Simultaneously in the early 20s, Diego Rivera (1886–1957), José Clemente Orozco (1883–1949), and David Alfaro Siqueiros (1898–1974) were developing in parallel.

Rivera's European apprenticeship from 1907 to 1921 had left him with a determination to deal with Mexico and its cultural revolution in a way that would draw from and nourish the masses. Where his European paintings had worked their way through figurative and cubist studies, his early Mexican murals, such as that done in 1922 at the National Preparatory School, began to show the emergence of his own Mexico.

pls. 12 & 13
pls. 8 & 9

pl. 27
pl. 47

The photographs of Alvarez Bravo document a similar shift of interest from the European to the distinctly Mexican. Early images such as the *Juegos de papel* (Paper games), *Arena y ramas* (Sand and branches), and *Roca cubierta de liquen* (Rock covered with lichen) are studies based upon a fascination for cubist and oriental formalism. It is in works such as *Paisaje y galope* (Landscape and gallop) of 1932 and *Muchacha viendo pájaros* (Girl watching birds) of 1931 that Alvarez finds his Mexican voice, one obviously not so socially conscious as that of the muralists, but one which, nonetheless, bases itself firmly in America. What European influence remains is primarily formal. The drive is now clearly Mexican.

Within the new sensibility two distinct energies were immediately apparent, one responsive to the direct power and violence of the Revolution itself, expressing a conscious, if insular, nationalism. This attitude informs the murals of Orozco and Siqueiros especially. The harsh color, violent action, and overall immediacy are indicative of torn and bloody Mexico still screaming for continued social and political change even after the fighting had stopped. In contrast is the refined, characteristically introspective art associated with the writers José Gorostiza (b. 1901) and Xavier Villaurrutia (1903–1950) and the painters Julio Castellanos (1905–1947) and Rufino Tamayo (b. 1899). From 1928 through 1931 the magazine *Los contemporáneos* (The Contemporaries) was the primary vehicle for the more intellectual and cosmopolitan elements in the art of the time. Aiming for a balance between the Mexican and the international, the work of these artists is filled with the interplay of images and abstractions, generally strengthened by an acute sense of irony; throughout, emotion is consciously controlled. It is this sensibility that seems to lie behind the photographs of Manuel Alvarez Bravo. Removed from the direct violence of the Revolution, artists such as Villaurrutia and Alvarez Bravo were to synthesize most effectively the old and the new, Europe and native Mexico. They did not consciously oppose the direction of Azuela and the muralists, but their characteristic subtlety, their more intellectual and literary approach owes much to both cultures. They knew Nerval, Baudelaire, Blake, Góngora, and their own contemporaries Cocteau, Breton, Eliot, Gide, yet they embodied Mexico. Their work at its best achieves an independent synthesis unlike any work that precedes it.

Their subject matter is generally shared, the predominant obsession being death. After years of war, death could not but be crucial to the vision of life held by all

Mexicans. The muralists had infused their work with its presence in a way similar to that of the "popular" artist José Guadalupe Posada. But in Villaurrutia and Alvarez one senses a very different attitude toward the subject. Here death is never treated simply as an active force. Its presence is pervasive and unyielding, not seen so much as felt. Villaurrutia, in the catalogue accompanying Alvarez Bravo's 1945 exhibition at the Society of Modern Art in Mexico City, noted this tendency:

> . . . *la presencia de la muerte en las fotografías de este poeta de la imagen no tiene sentido caricaturesco o acento macabro ni intención humorística o satírica, como en la obra de nuestros grabadores populistas; ni un dramático sentido del horror como en las pinturas y grabados de José Clemente Orozco, sino un evidente sentido poético.*

> . . . the presence of death in the photographs of this poet of the image has no sense of caricature or accent of the macabre, nor a humoristic or satiric purpose, as in the work of our popular illustrators, nor a dramatic sense of horror as in the paintings and illustrations of José Clemente Orozco, but, rather, an obvious poetic sense.

Here death is not the negative death assumed by most of Western culture, but, rather, a positive element which is especially Mexican and particularly Indian. Its steady tension lies behind the work as a whole. Straightforward photographs such as *Enterramiento en Metepec* (Burial in Metepec), the metaphoric *Escala de escalas* (Ladder of ladders), even *Sábanas* (Sheets) and *Un poco alegre y graciosa* (Somewhat gay and graceful) express a musicality founded upon this counterpoint of death to life. Even in the more obvious images such as *Obrero en huelga asesinado* (Striking worker murdered) and *Día de matanza* (Slaughtering day), death is a calm presence. The striking worker conveys tranquility despite the brutality of his death. Alvarez has approached his subject with a sense of wonder and respect. He is not documenting violence so much as reflecting upon it. In his work one senses the photographer coming upon the event after the event itself has transpired. Alvarez has often related that as a child he would in his walks occasionally come upon the dead of the Revolution, and it is thus that he seems to discover the subjects of his photographs. He learns from the aftermath. He shows the periphery, the sense of the simple and eternal which persists despite the act, and he does so with sufficient irony to avoid sentimentality. These attitudes are especially noticeable in *El soñador* (The dreamer), *Acto primero* (Act one), *Los cueros* (The wineskins). The feeling of the philosophic aside permeates his work.

pl. 3
pl. 11
pls. 41 & 65

pl. 45
pl. 61

pls. 40, 57, & 66

Alvarez' work is peopled by the Indian and the peasant; they inhabit their world without noise or action. They are the figures who silently project a timelessness intrinsic to Mexico. It is important that Alvarez' photographs seldom show anything that would give them specificity of time or place: the boy drinking in *Sed pública* (Public thirst), the woman of *Caja de visiones* (Box of visions) could be of any time.

pls. 63 & 79

Throughout the Spanish world of the 30s there was a growing use of the native elements of each culture as subject for art. This interest paralleled the experiment with primitive art by European artists such as Modigliani and Picasso. Yet even within this tendency, Alvarez' particular focus seems especially individual. His use of the Indian peasant is more fundamental than García Lorca's (1898–1936) use of the Spanish gypsy or than Nicolás Guillen's (b. 1902) use of the Caribbean black simply because in Alvarez' hands the Indian seems so much the very blood of the land itself; his permanence becomes subject. Unlike the muralists Alvarez does not dwell upon the social injustice suffered by his subjects; he never lets the political as such interfere with his art. The persistent tranquility of the people in his photographs asks nothing, but rather seems reflective of an existence, a philosophic condition to be assumed. Unaffected by change, integral to their earth, these peasants, these Indians, are directly equated by Alvarez to their progenitors, the Aztec and the Maya. His carefully selected titles enforce this equation, occasionally making direct reference to the creation myth of the Maya, the *Popol Vuh*, the early Spanish transcription of the Mayan *Libro del consejo*. *Los Creadores, los Formadores* (The Creators, the Formers) and *La abuela, nuestra abuela* (The grandmother, our grandmother) are titles taken directly from the Mayan books. This literary sense invades the work through the titling and adds significantly to the visual implications of the images themselves. More often than not, the titles extend the implications of the photographs, becoming metaphoric, drawing the viewer to relationships beyond the purely photographic. And it is this literary aspect, along with the exotic nature of the work, that makes Alvarez Bravo's photographs yield only slowly to understanding. Though there are individual photographs which are easily accessible, such as *La quema tres* (Kiln number three), *Paisaje cáctico* (Cactus landscape), *Calabaza y caracol* (Squash and snail), the greater number offer a certain resistance. *Y por las noches gemía* (And by night it moaned), *Gorrión, claro* (Sparrow, clearly), *Sueño en las ruinas* (Dream in the ruins) call for an awareness beyond the perception of the image itself.

not shown pl. 7

pl. 37 pls.14 & 34 not shown pls.32 & 30

In examining Mexican art since the Revolution, one is confronted with a powerful regional vocabulary. Ultimately one comes to the question of whether this predominant strength is also a limitation. If the work does not translate to a broader context, it is restricted. The Mexican writer Juan Rulfo (b. 1918), often equated to William Faulkner, is in a position similar to that of Alvarez. His stories *El Llano en*

Llamas (The Plain in Flames) and his novel *Pedro Páramo* deal with a totally regional Mexico, denying any allusion to a world without. Faulkner's Yoknapatawpha County, Rulfo's *llano*, Alvarez' pueblo, all demand of the reader and viewer that he see the world presented without preconception and that he do the work of understanding the fine grain of the regional and of fixing the universal within it. It is only after this effort that one can see Alvarez Bravo's photographs clearly; when the difficulty of his language is overcome, the work as a whole focuses into a belief, an attitude. It then becomes apparent why the photographer prefaced his own essay in the 1945 catalogue with a description from the *Popol Vuh* of that mythic first race of men who were destroyed by their makers because of their lack of purpose:

> *No tenían ni ingenio ni sabiduría, ningún recuerdo de sus Constructores, de sus Formadores . . . por eso decayeron. Solamente un ensayo, solamente una tentativa de humanidad. . . .*

> They had neither talent nor knowledge, not one remembrance of their Makers, their Formers . . . because of this they decayed. (They were) only an exercise, only an experiment in humanity.

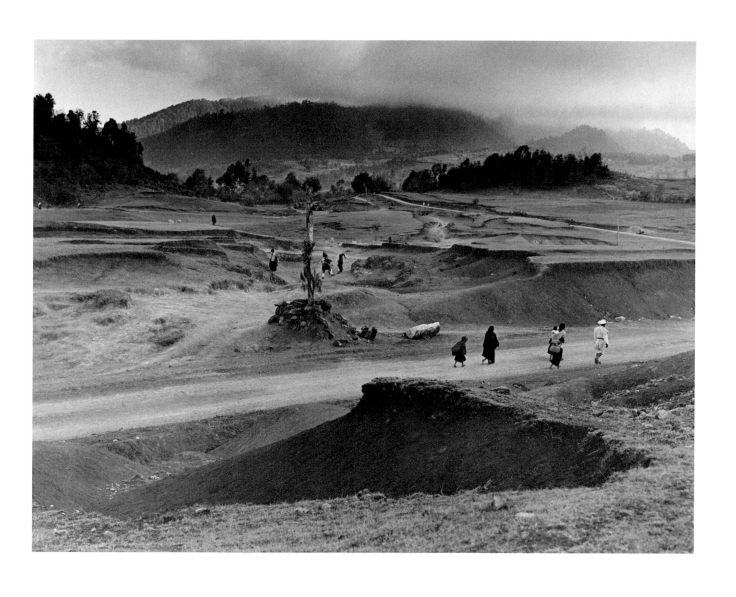

I
Paisaje Chamula con dos grupos
Chamula landscape with two groups

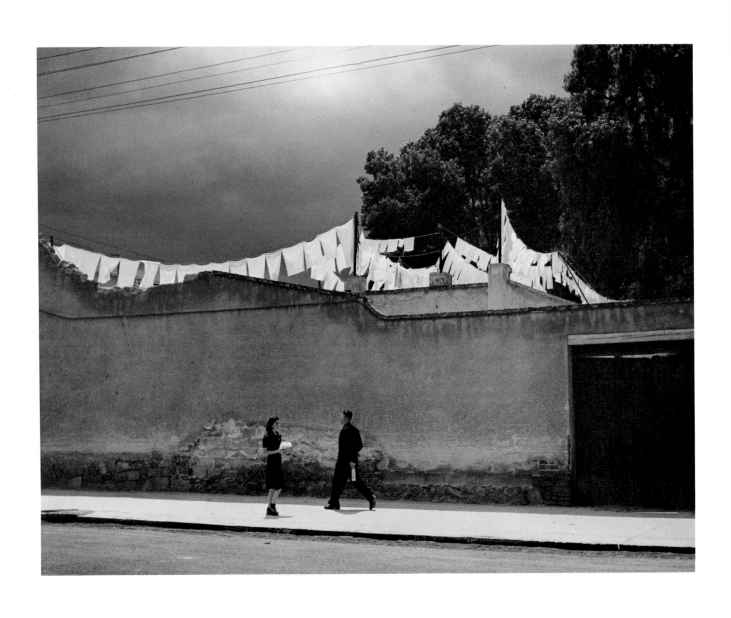

2
Que chiquito es el mundo
How small the world is

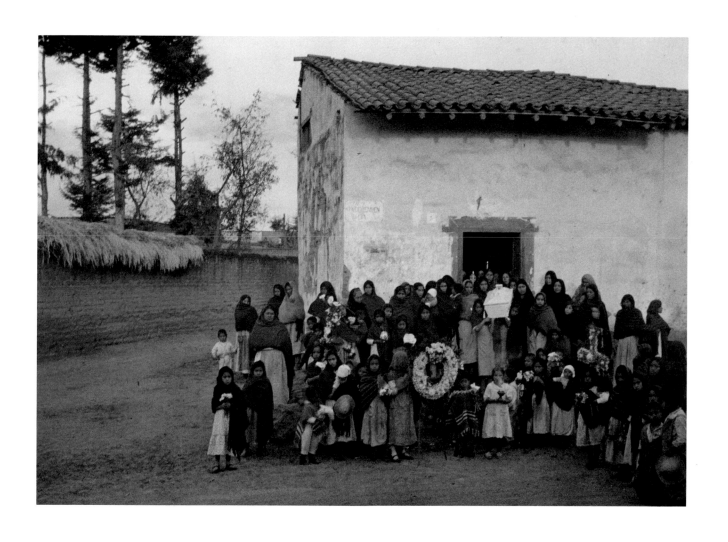

3
Enterramiento en Metepec
Burial in Metepec

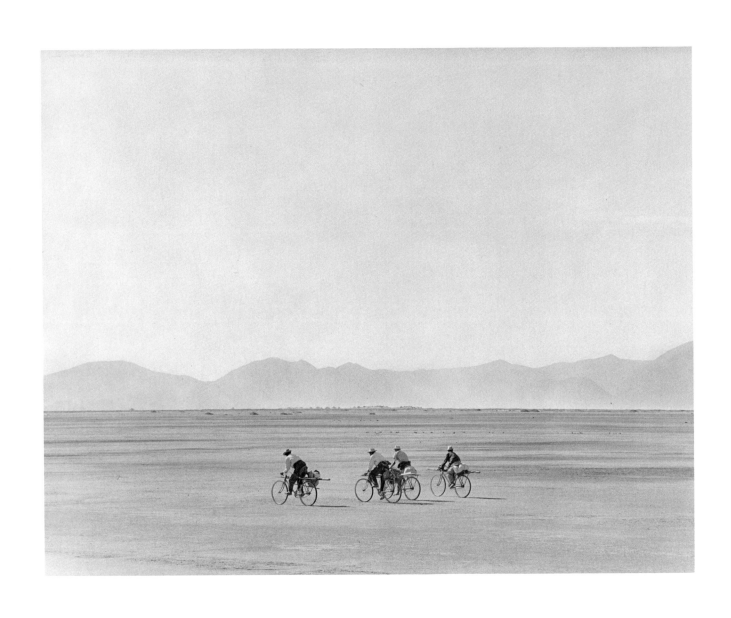

4
Bicicletas en domingo
Bicycles on Sunday

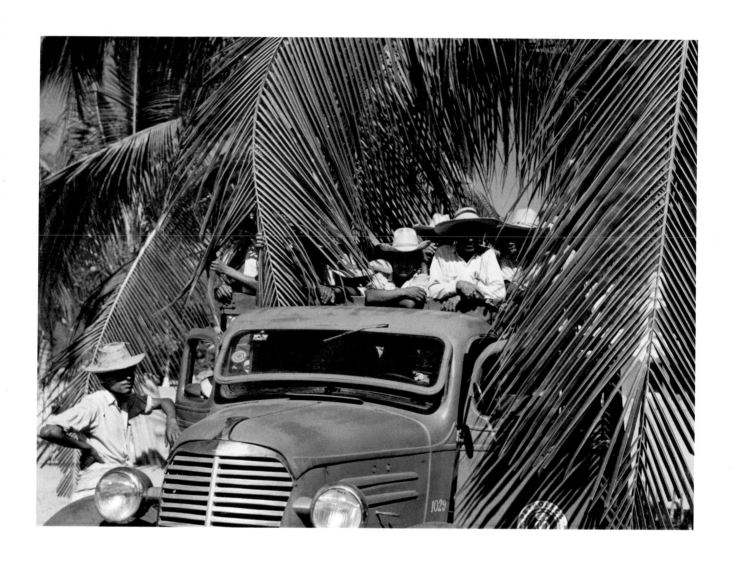

5
Trabajadores del trópico
Workers of the tropics

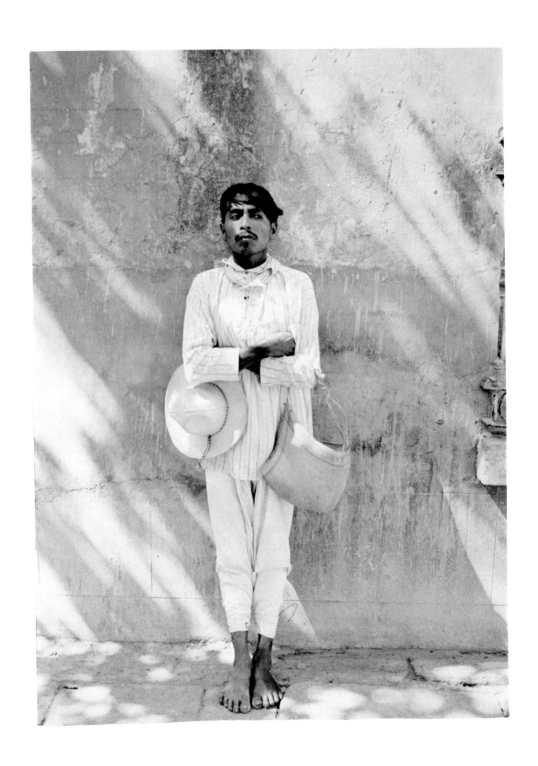

6
Señor de Papantla
Man from Papantla

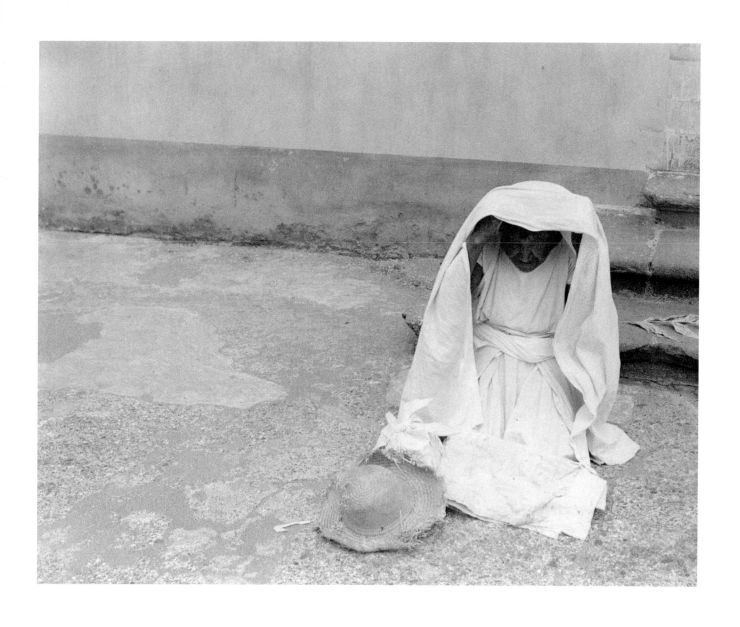

7
La abuela, nuestra abuela
The grandmother, our grandmother

8
Arena y ramas
Sand and branches

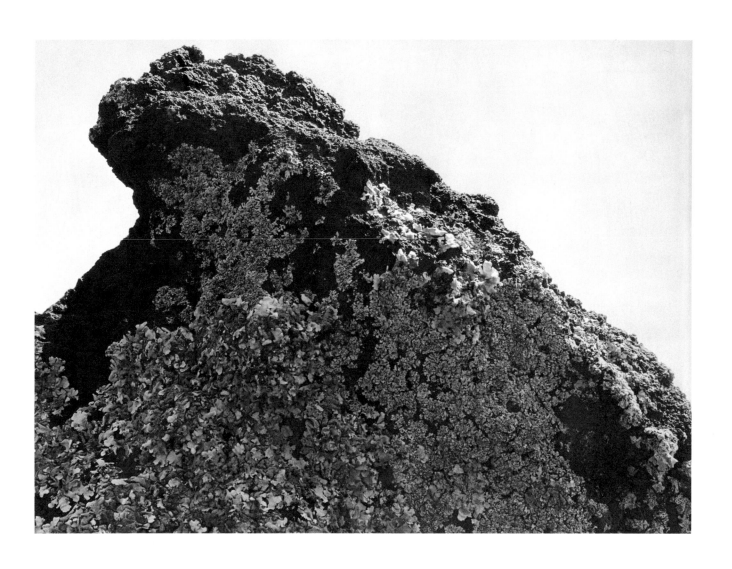

9
Roca cubierta de liquen
Rock covered with lichen

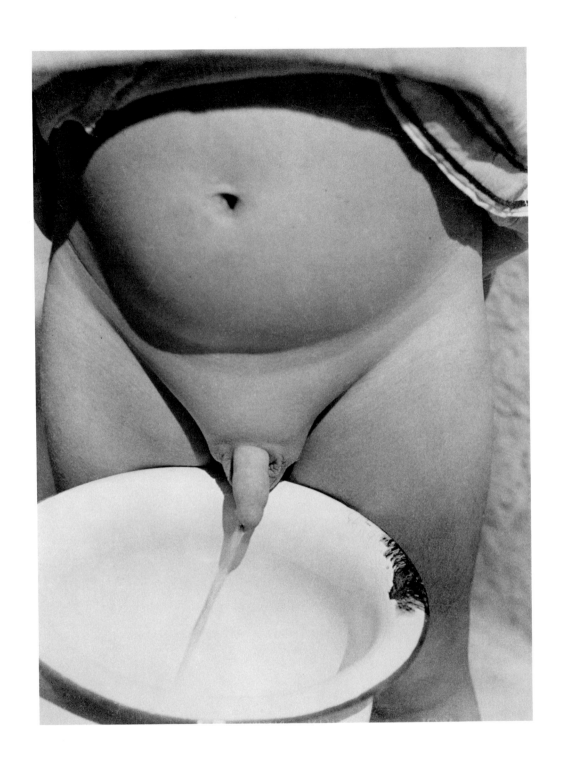

10
Niño orinando
Boy urinating

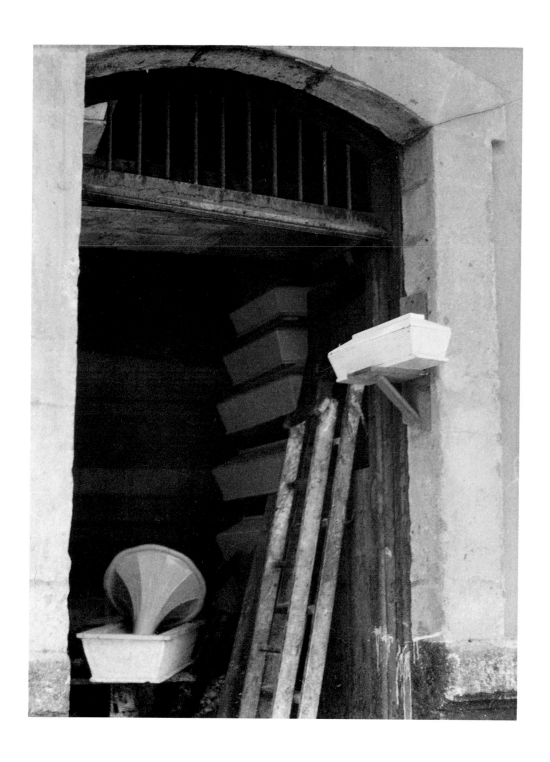

11
Escala de escalas
Ladder of ladders

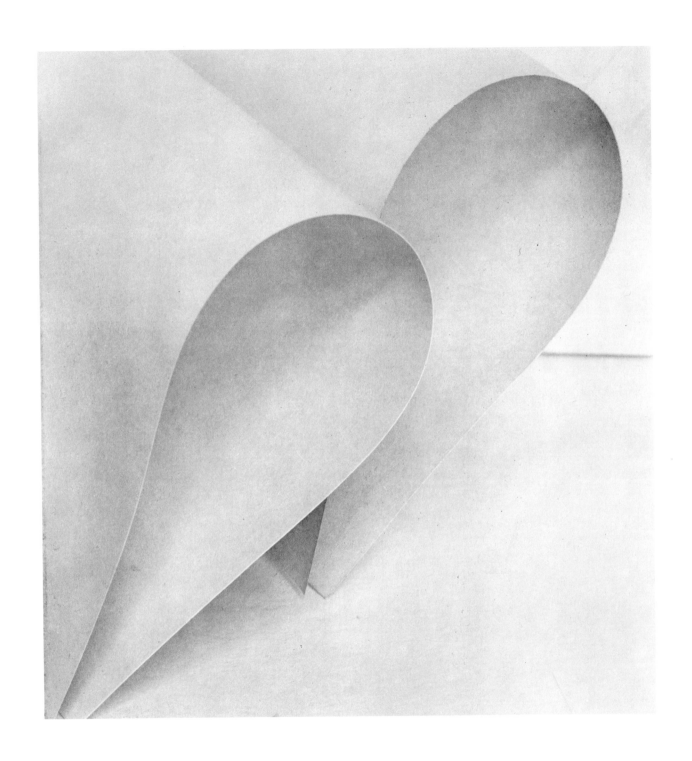

12
Juego de papel (3)
Paper game (3)

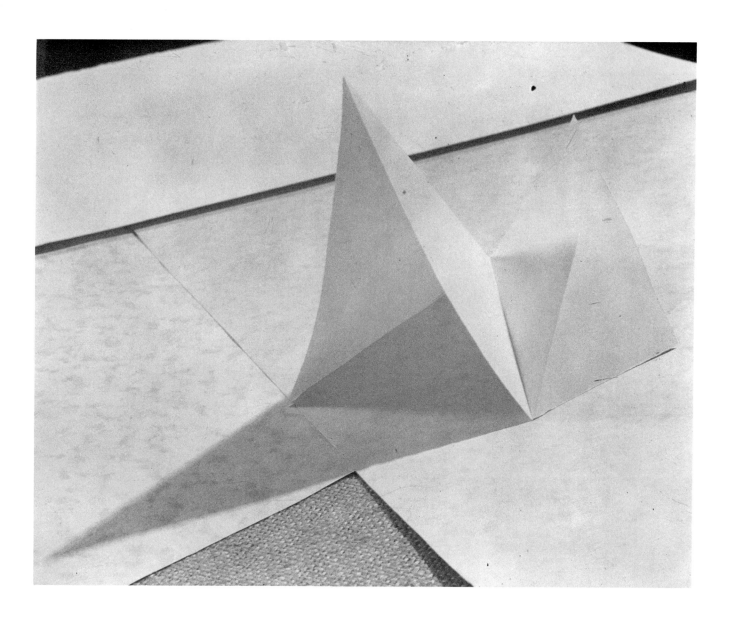

13
Juego de papel (2)
Paper game (2)

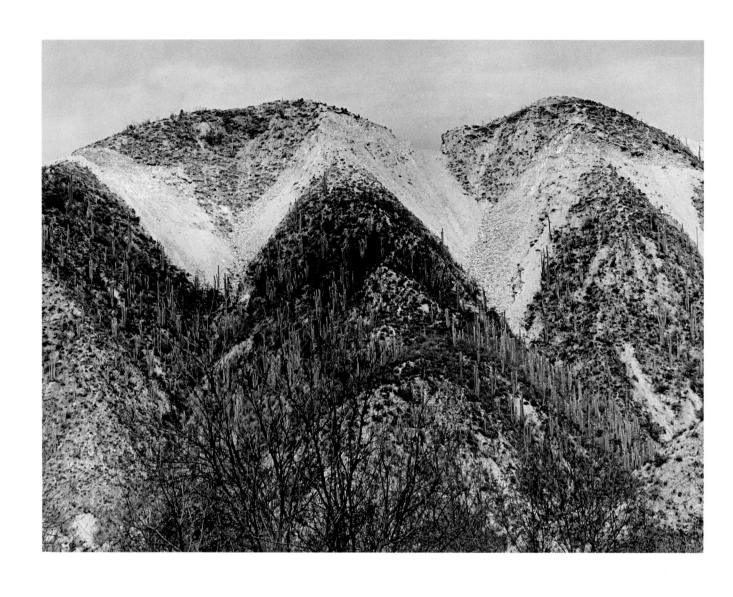

14
Paisaje cáctico
Cactus landscape

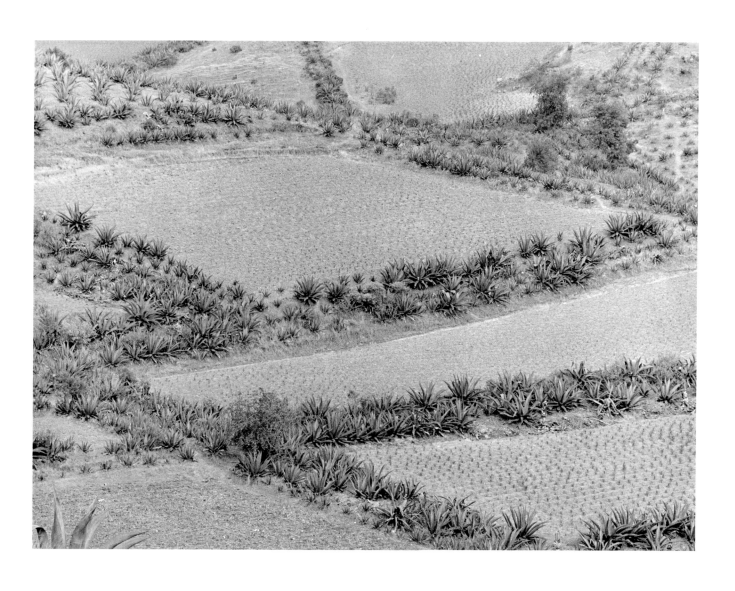

15
Paisaje de siembras
Landscape of sown fields

16
Elefante al cielo
Elephant in the sky

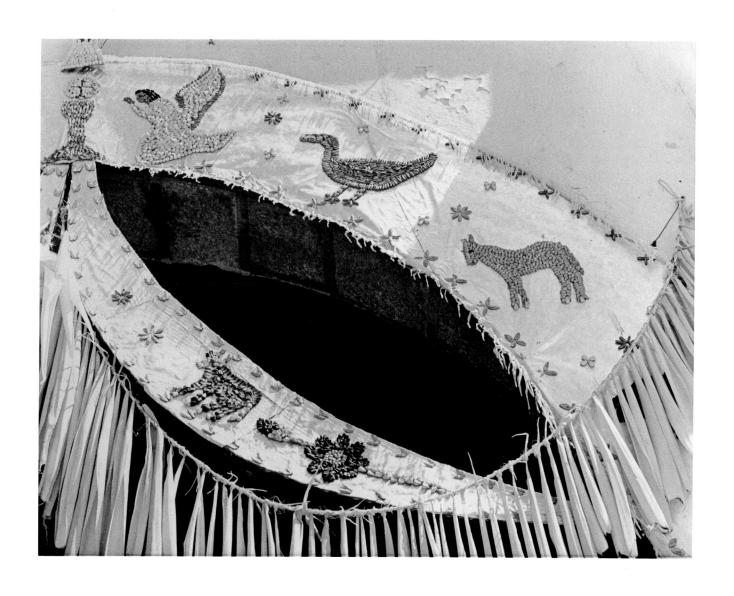

17
Votos
Votive offerings

18
Los obstáculos
The obstacles

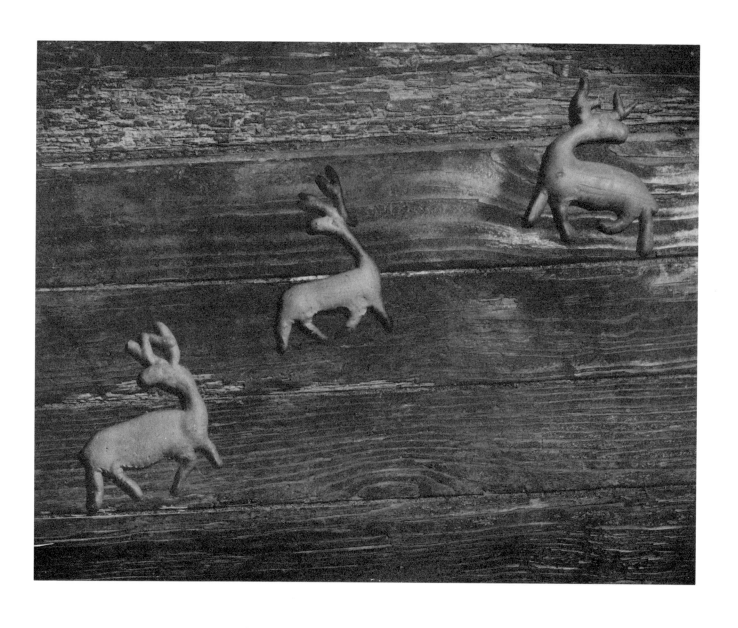

19
Los venaditos
The little deer
(palladium print)

20
Donde está la estrella
Where the star is

21
Luz restirada
Lengthened light

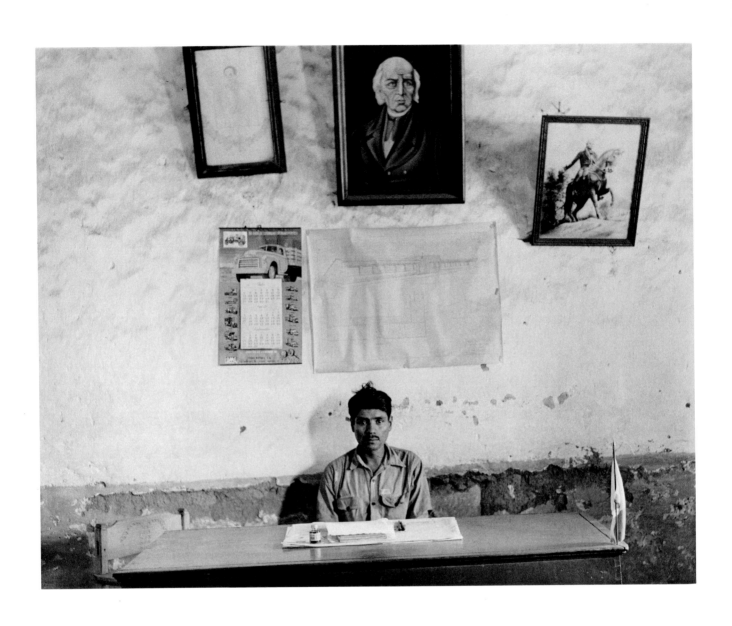

22
Señor Presidente Municipal
Mr. Municipal President

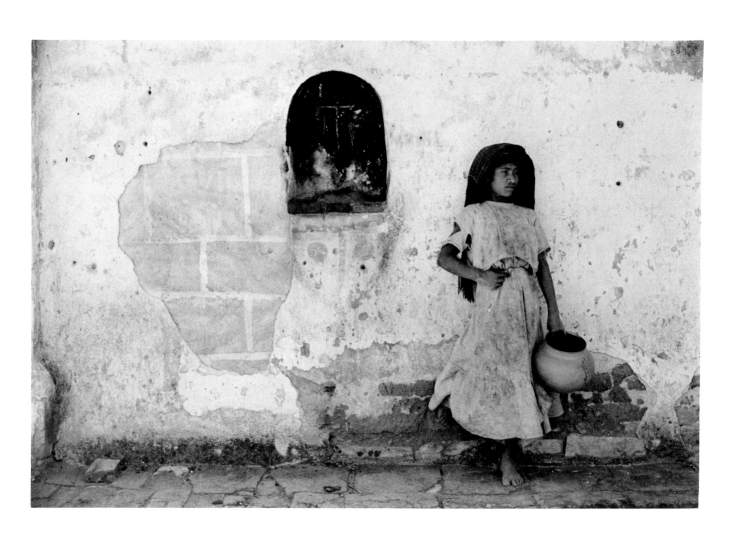

23
Recuerdo de Atzompan
Remembrance from Atzompan

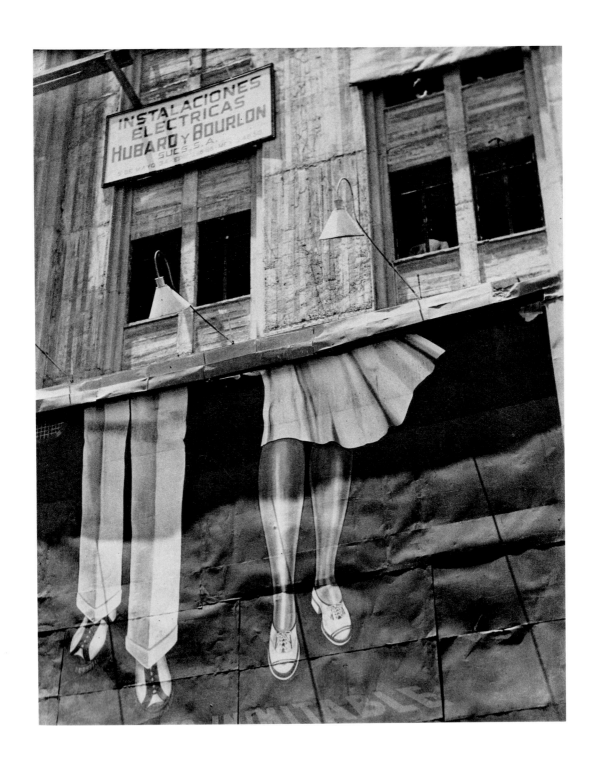

24
Dos pares de piernas
Two pairs of legs

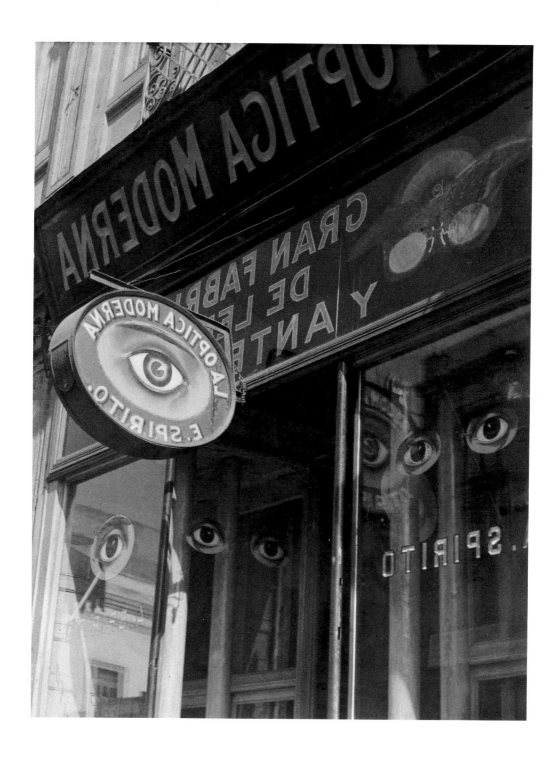

25
Parábola óptica
Optic parable

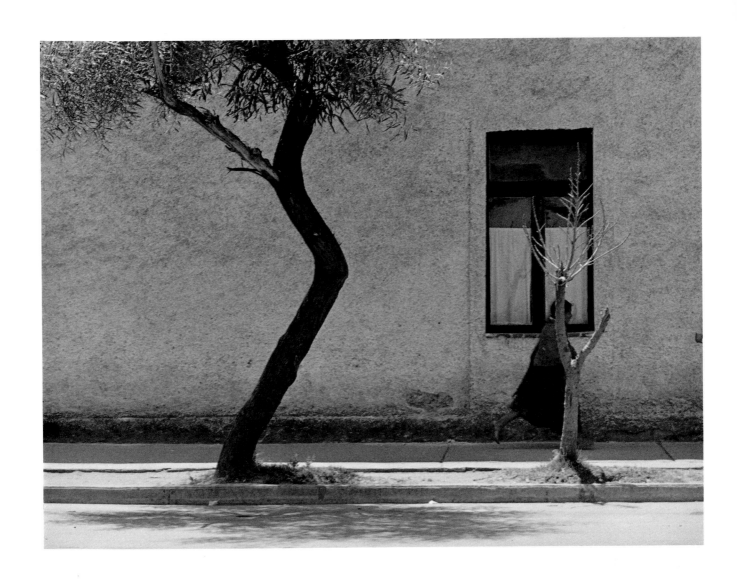

26
La María

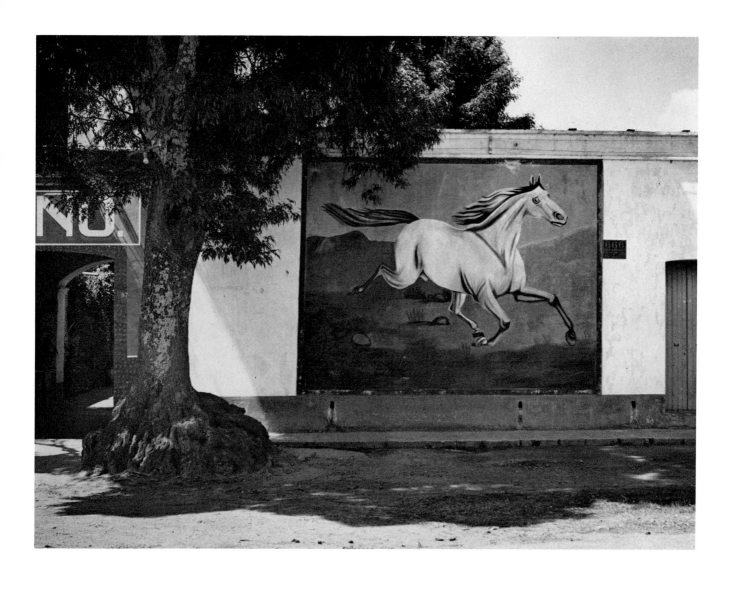

27
Paisaje y galope
Landscape and gallop

28
David Alfaro Siqueiros

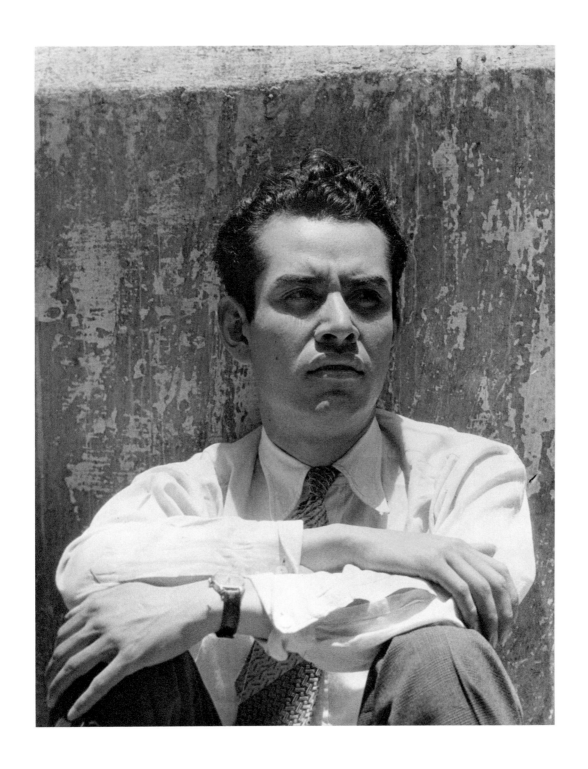

29
Rufino Tamayo

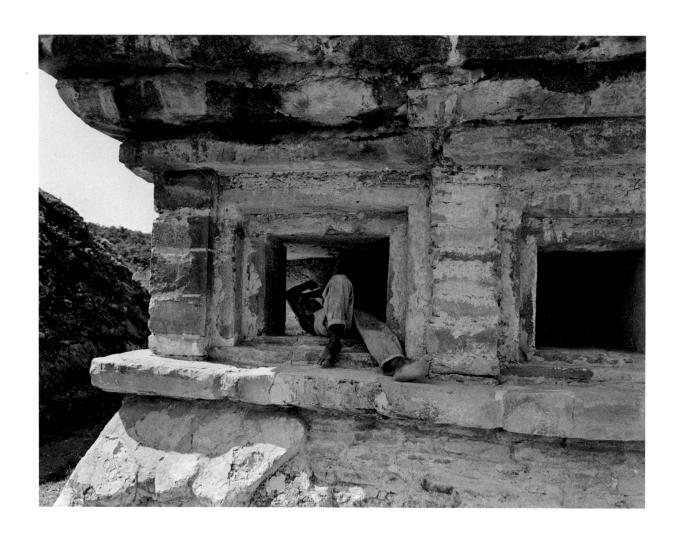

30
Sueño en las ruinas
Dream in the ruins

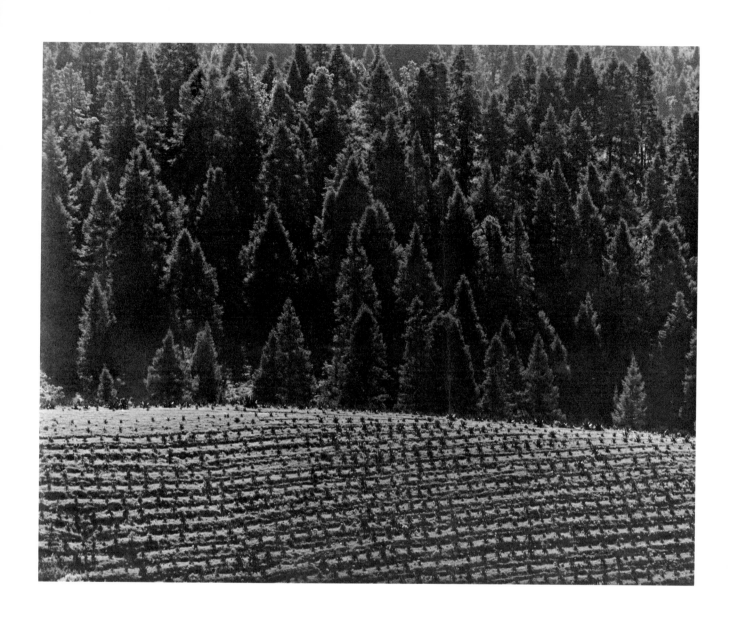

33
Siembra de magueyes (o: Siembra y bosque)
Sown agaves (or: Sown field and forest)

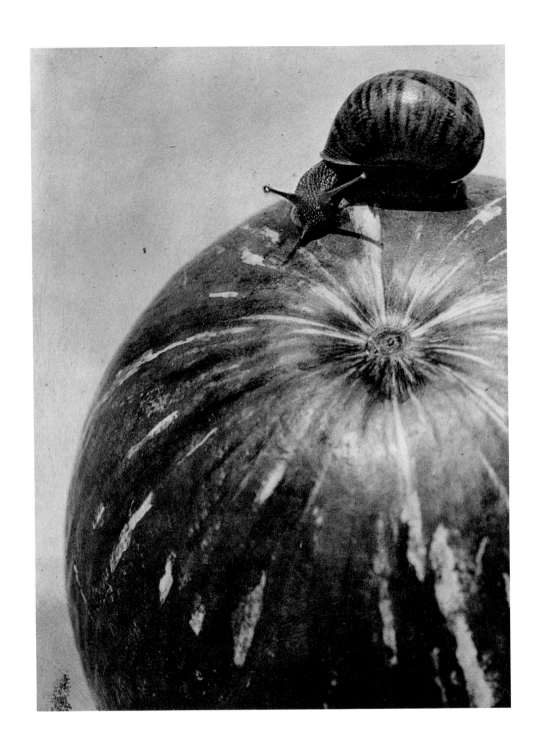

34
Calabaza y caracol
Squash and snail

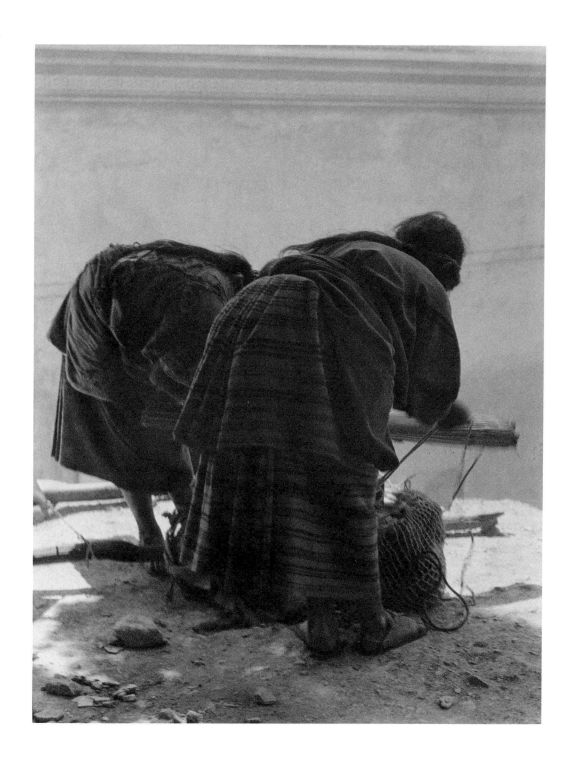

35
Fin de tianguis
End of market day

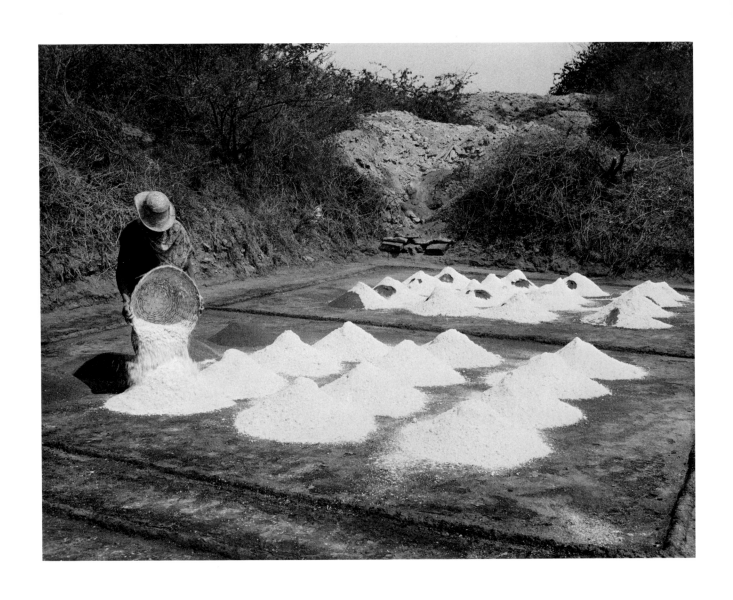

36
Salinero
Salt worker

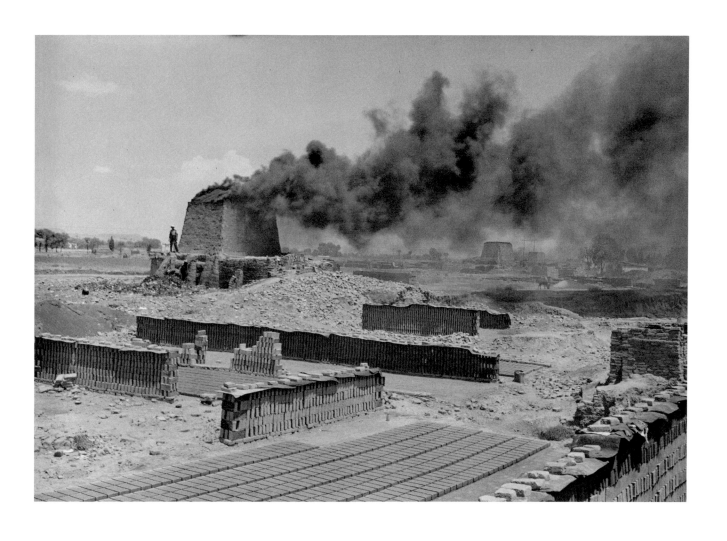

37
La quema tres
Kiln number three

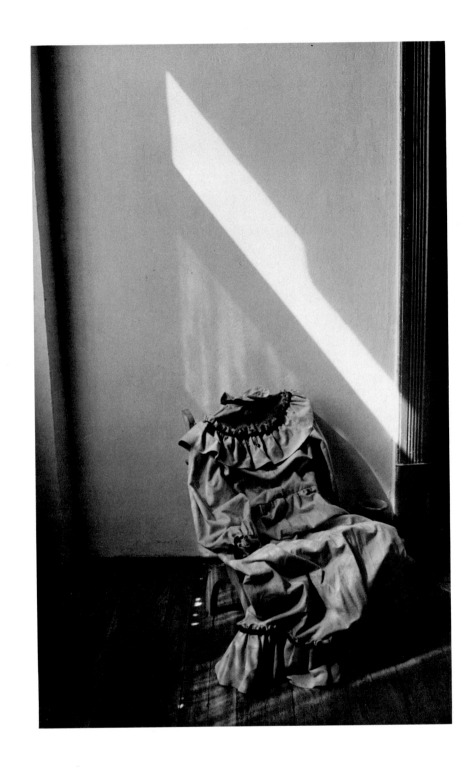

38
Retrato ausente
Absent portrait

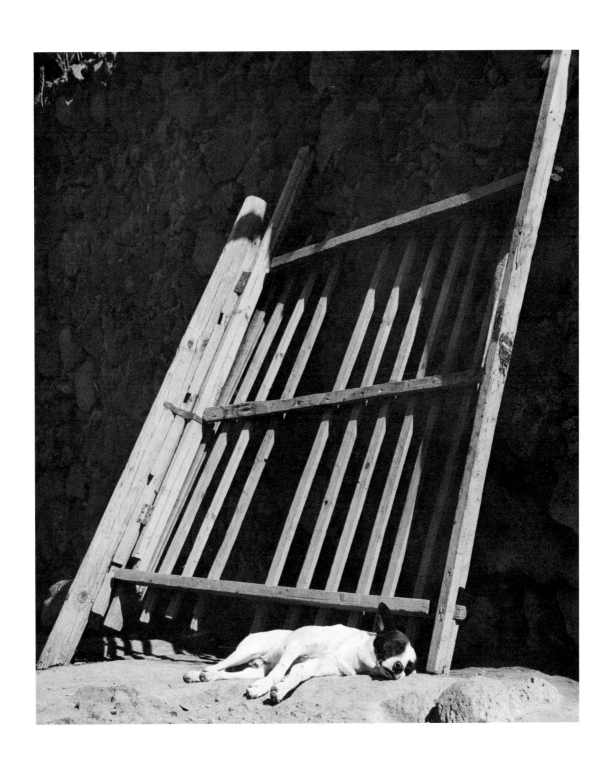

39
Justo sueño
Well-earned sleep

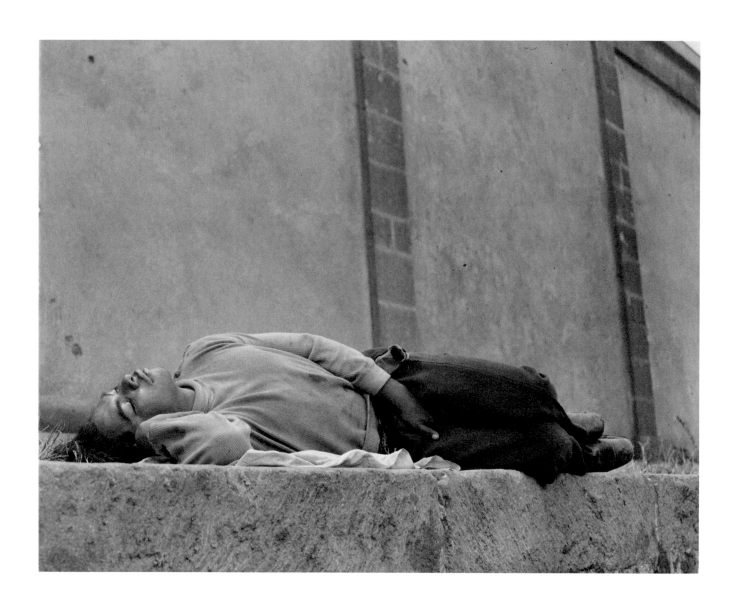

40
El soñador
The dreamer

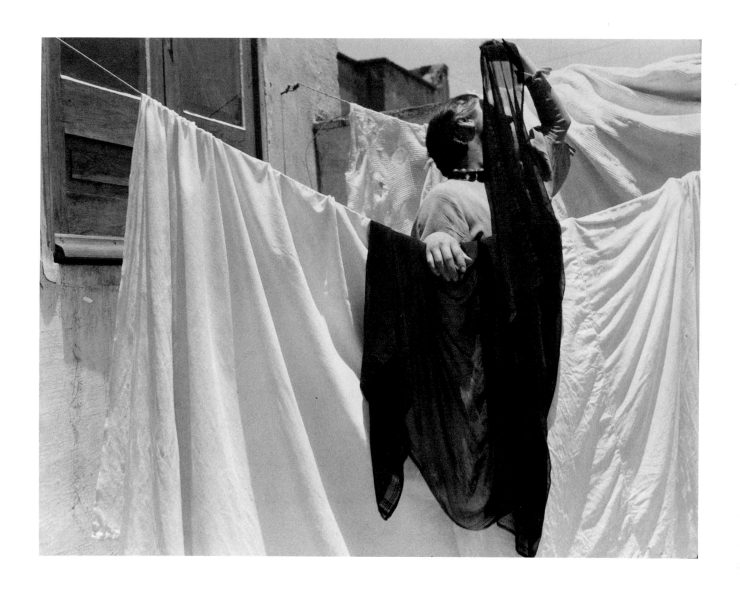

41
Sábanas
Sheets

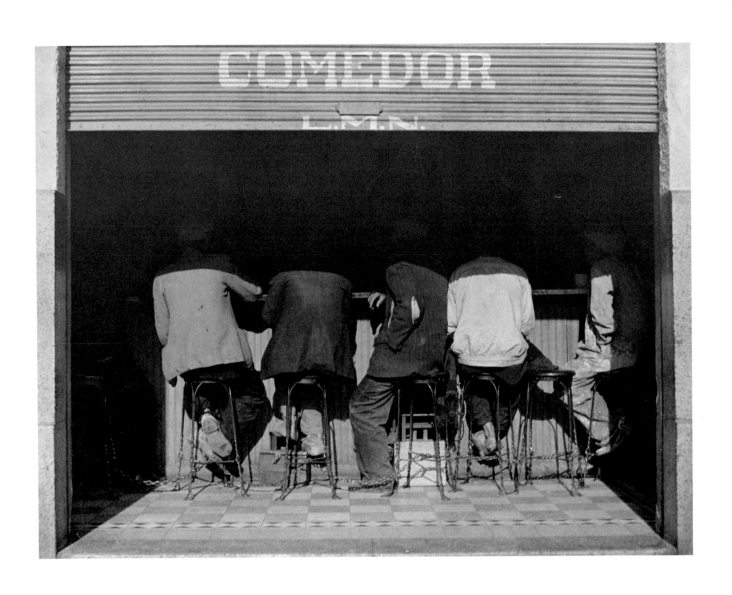

42
Los agachados
The crouched ones

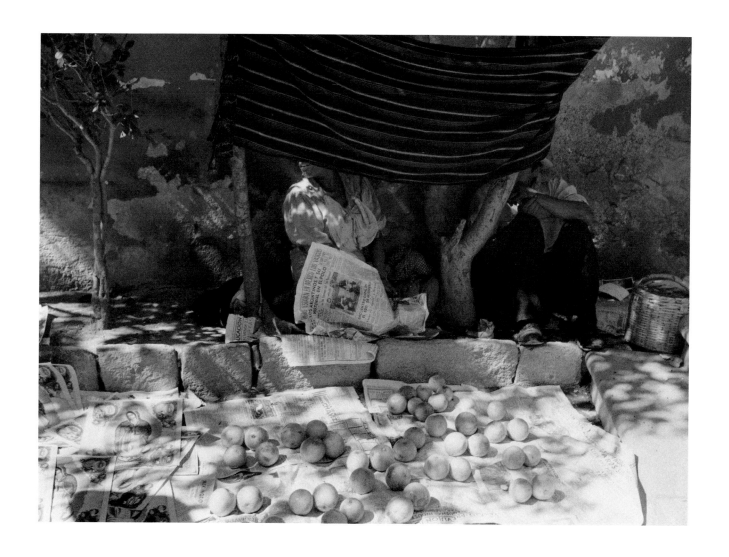

43
Trampa puesta
Set trap

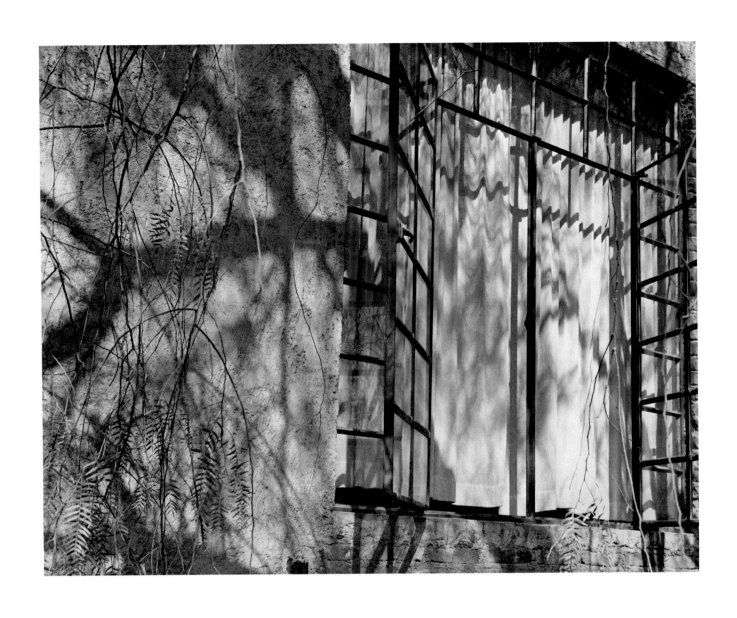

44
Ventana en la casa de usted (arrugas)
A window of your house (folds)

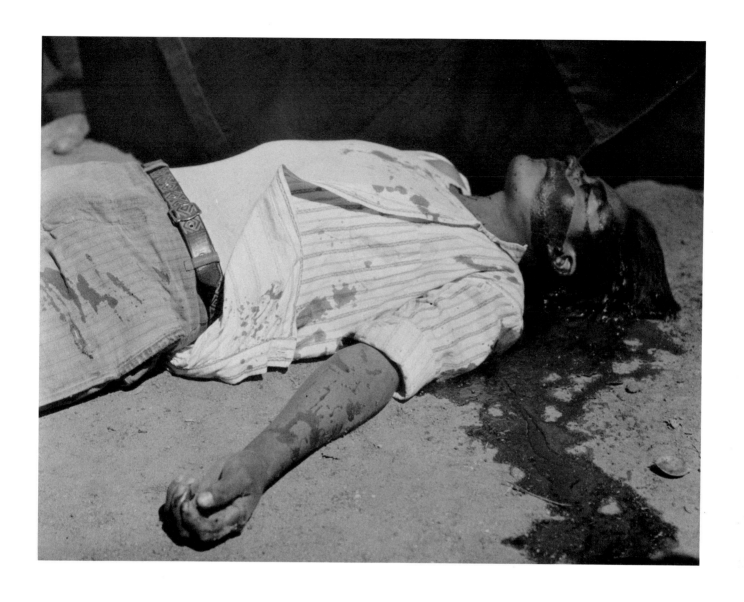

45
Obrero en huelga asesinado
Striking worker murdered

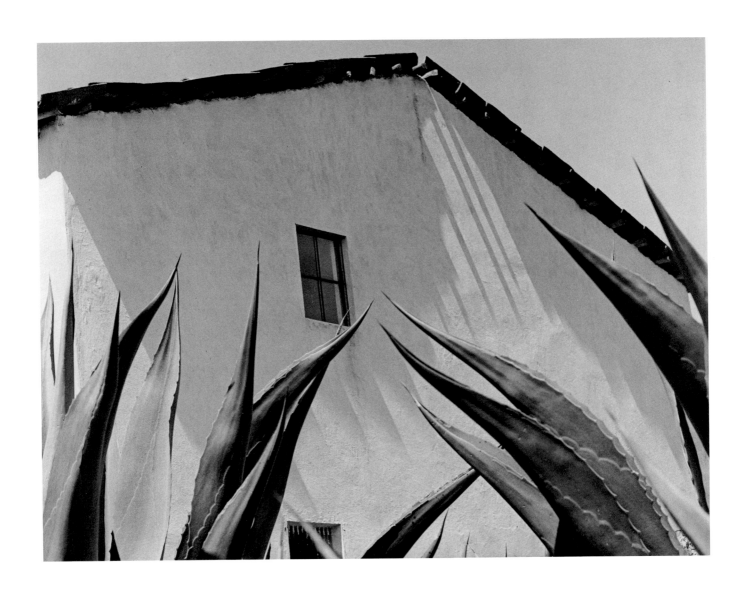

46
Ventana a los magueyes
Window on the agaves

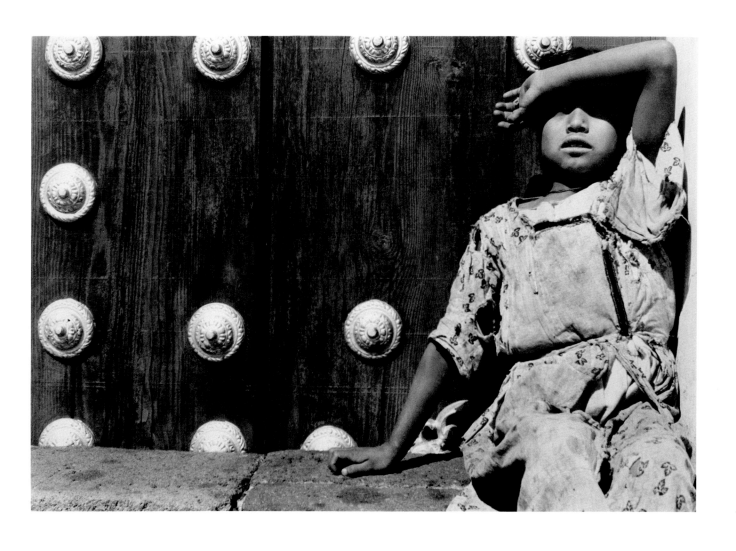

47
Muchacha viendo pájaros
Girl watching birds

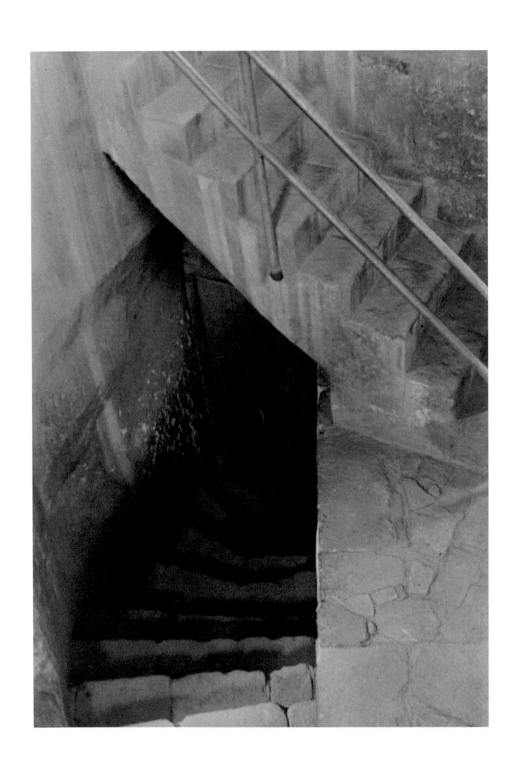

48
Escaleras de catedral
Cathedral stairway

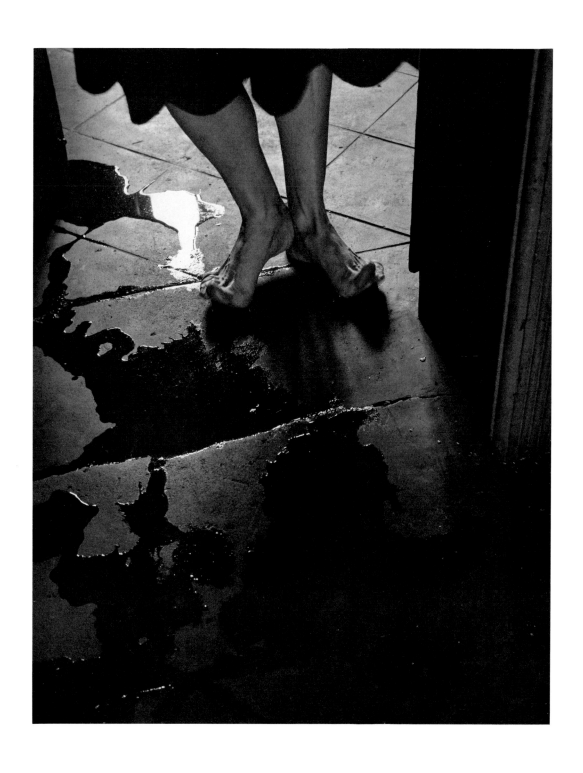

49
Pies con charco
Feet with puddle

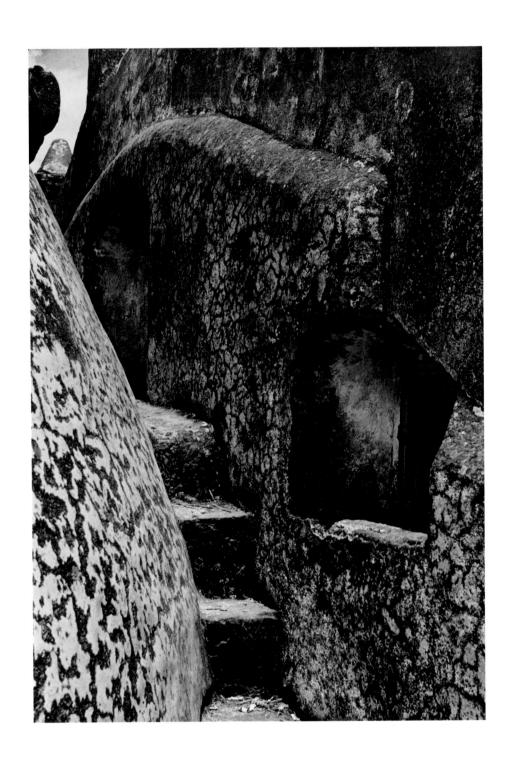

50
Ventana al coro
Window to the choir

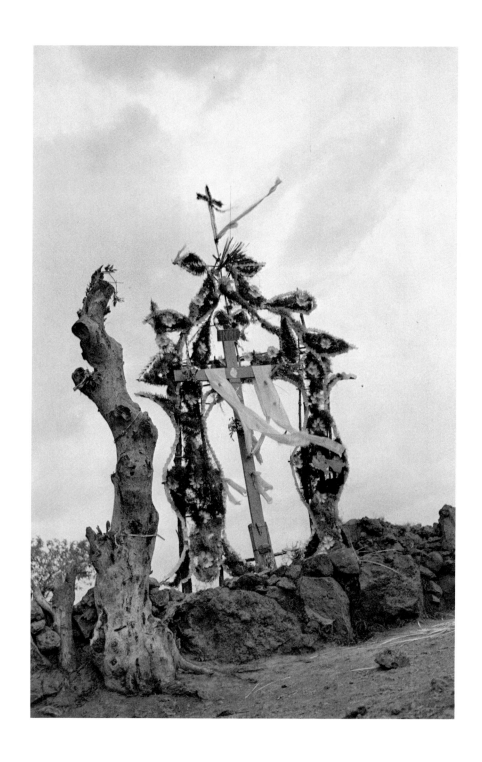

51
Cruce de Chalma
The crossing at Chalma

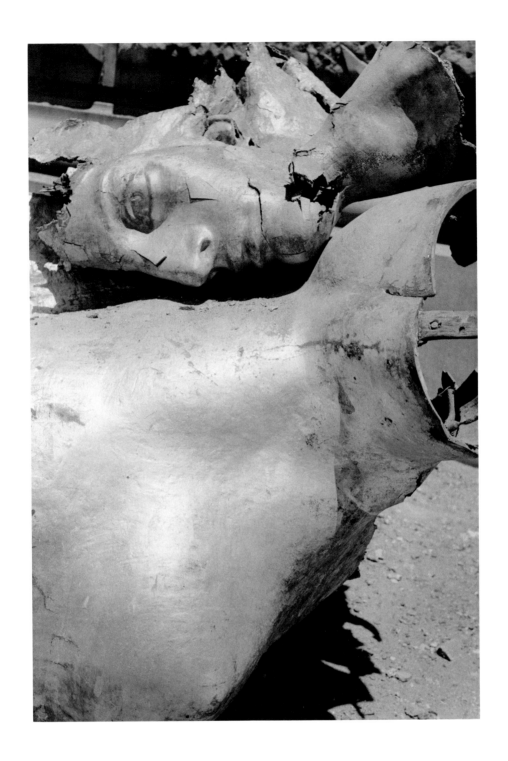

52
Angel del temblor
Angel of the quake

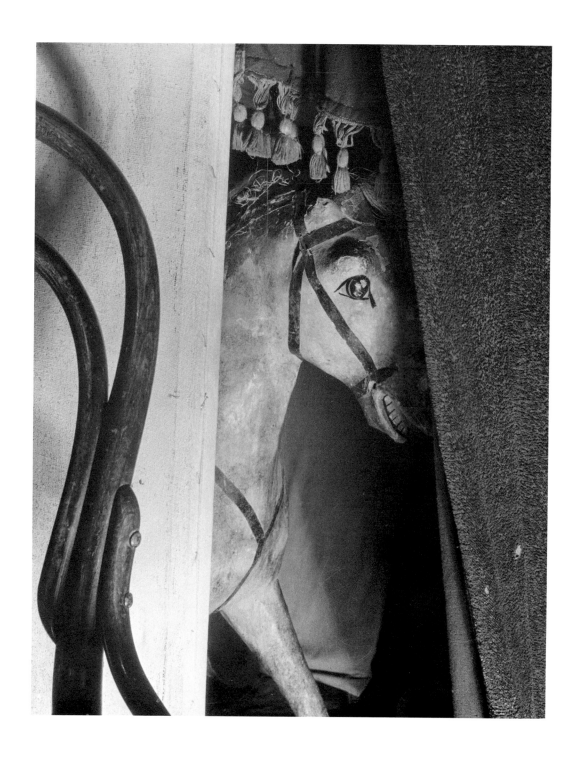

53
Caballo de madera, 1928
Wooden horse, 1928

54
El evangelista
The evangelist

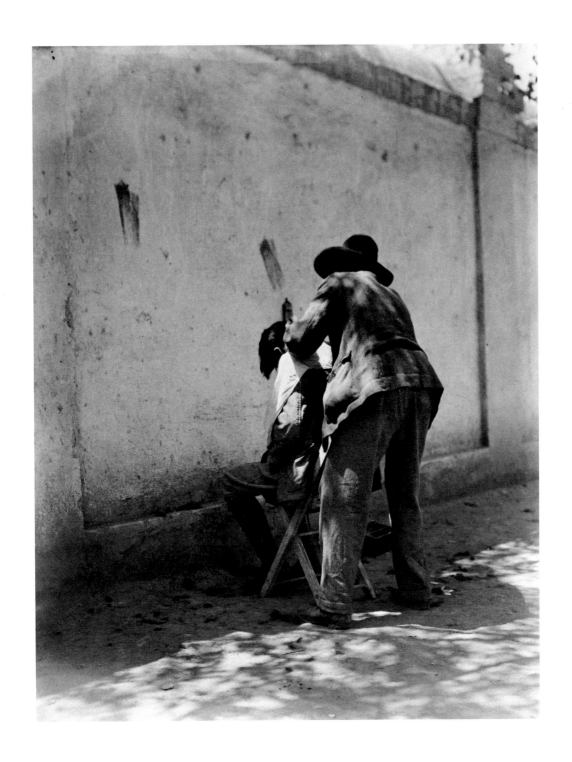

55
Peluquero
Barber

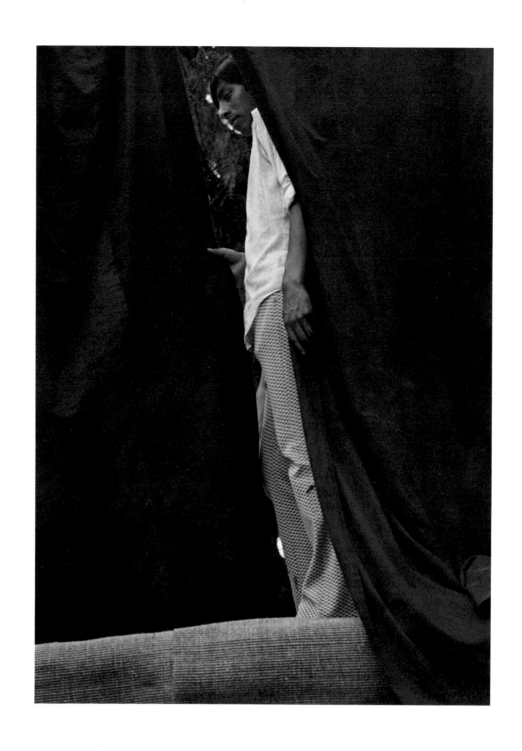

56
Intermedio
Intermission

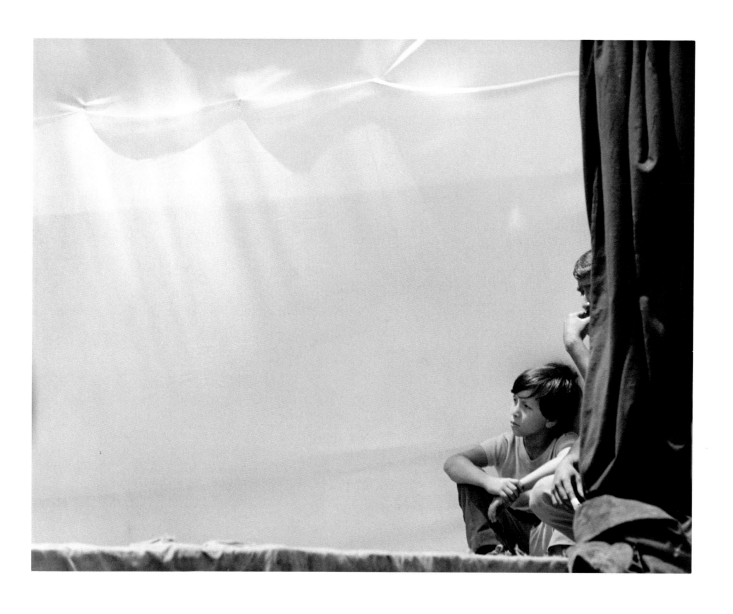

57
Acto primero
Act one

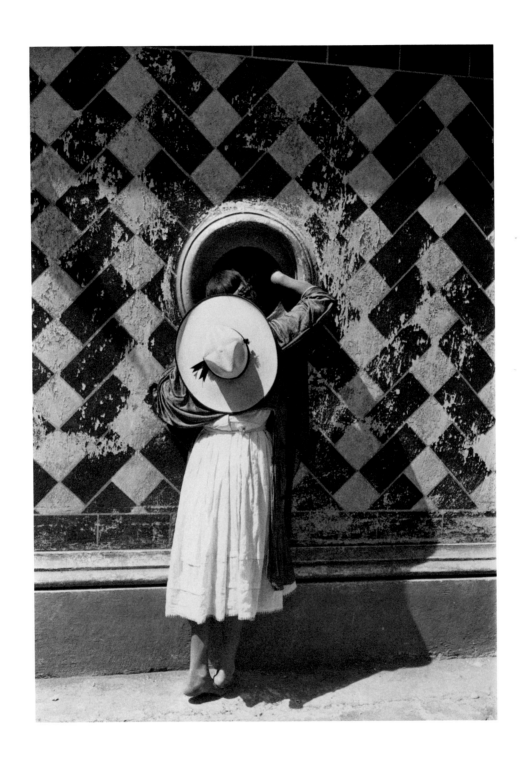

58
La hija de los danzantes
The daughter of the dancers

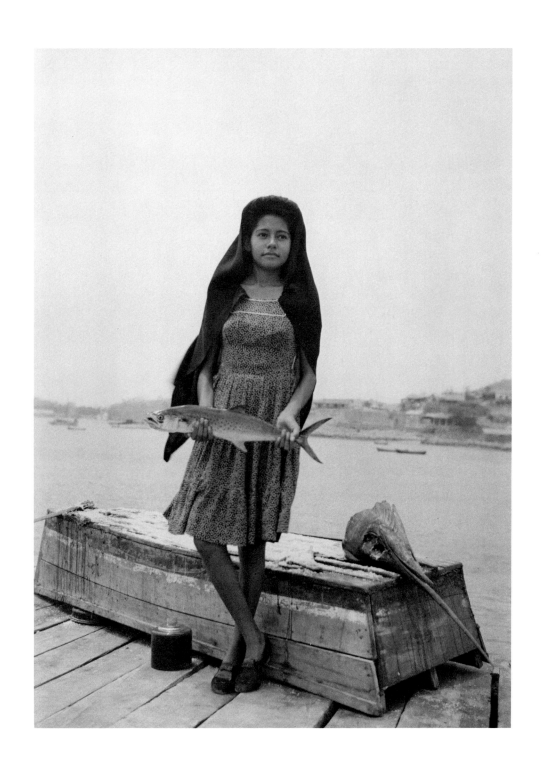

59
Un pez que llaman Sierra
A fish called *Sierra*

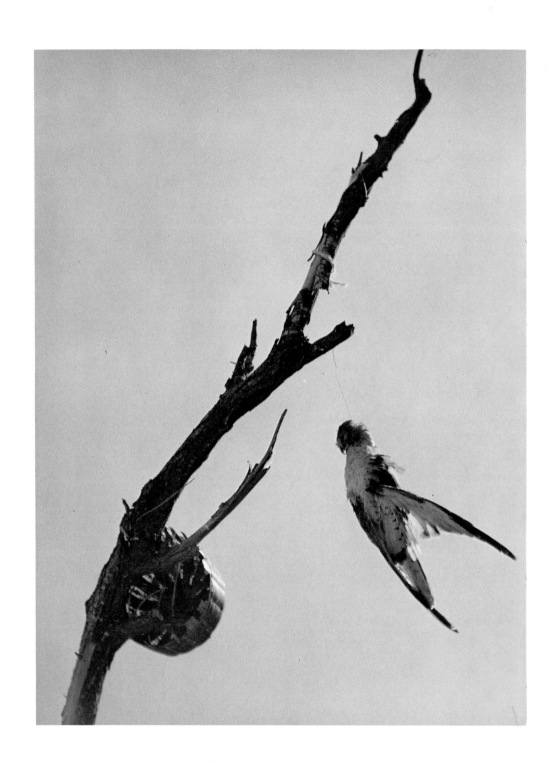

60
Pájaro crepuscular que mecido por el viento
Twilight bird swayed by the wind

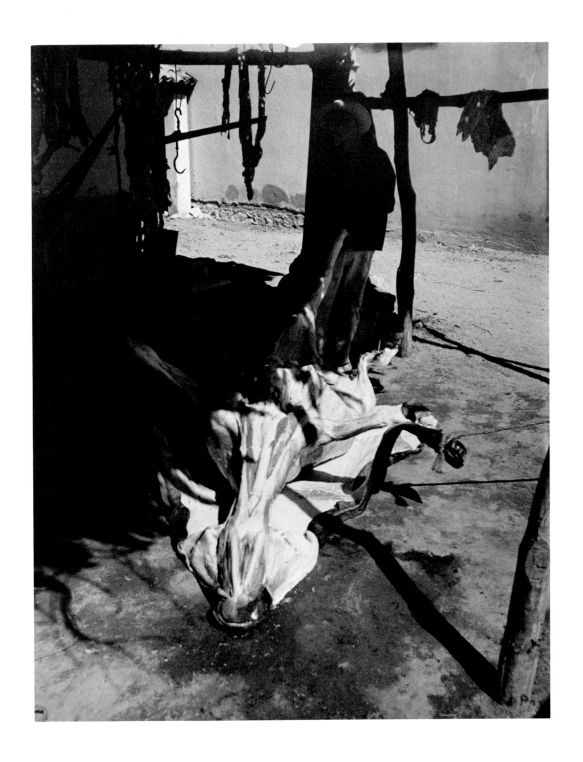

61
Día de matanza
Slaughtering day

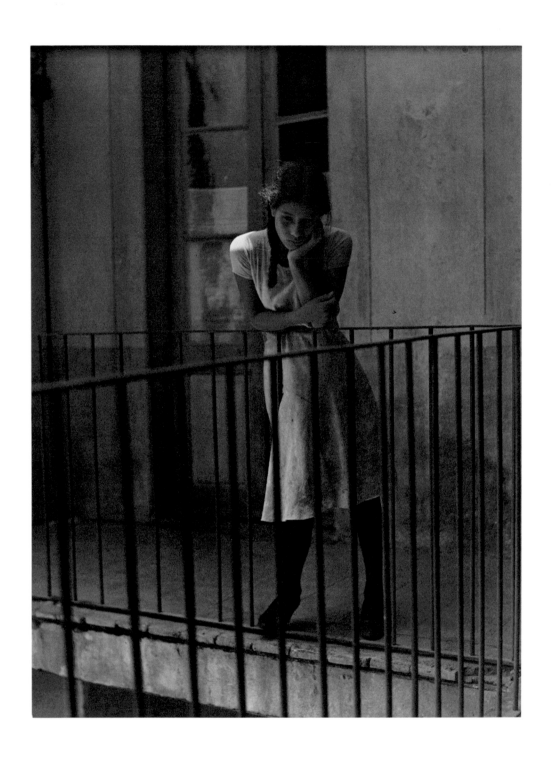

62
El ensueño
The daydream

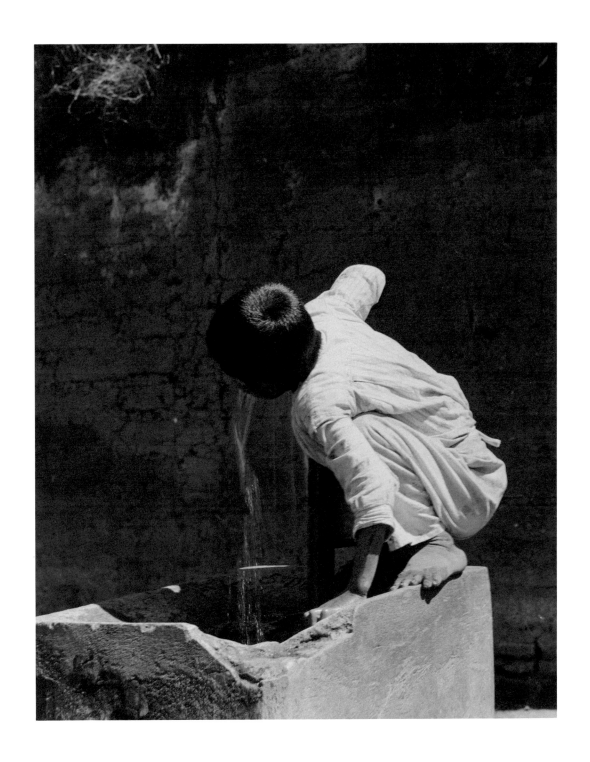

63
Sed pública
Public thirst

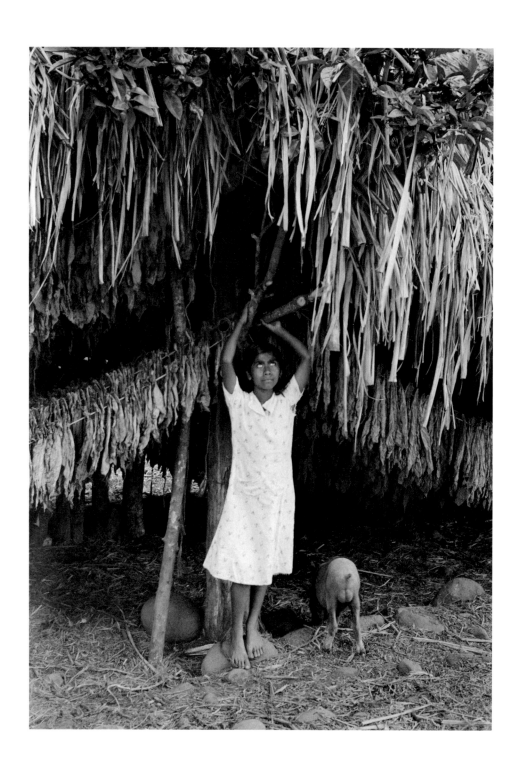

64
El tabaco
Tobacco

65
Un poco alegre y graciosa
Somewhat gay and graceful

66
Los cueros
The wineskins

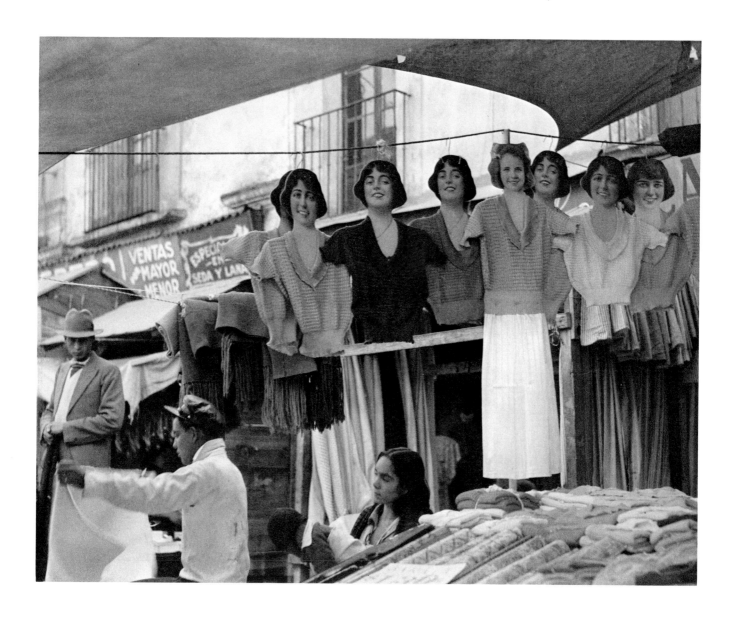

67
Maniquís riendo
Laughing mannequins

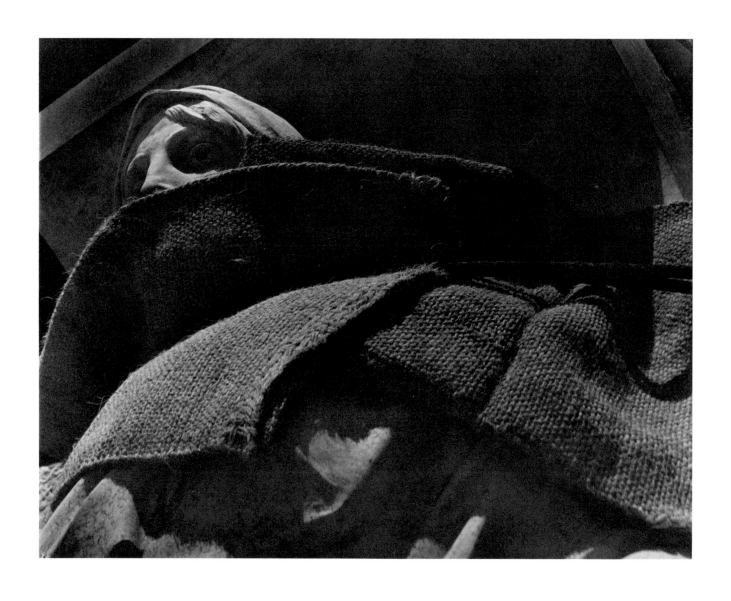

68
La de las Bellas Artes
She of the Fine Arts

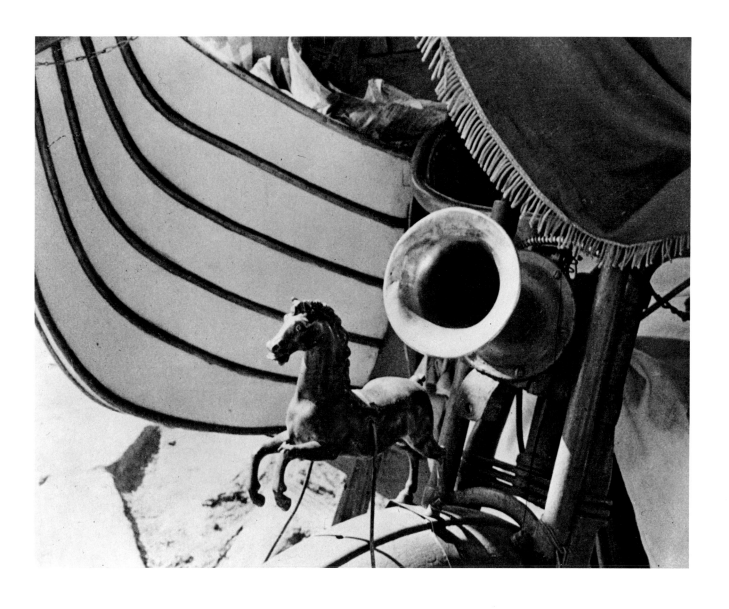

69
Caballito de carro de helados
Little horse on the ice cream cart

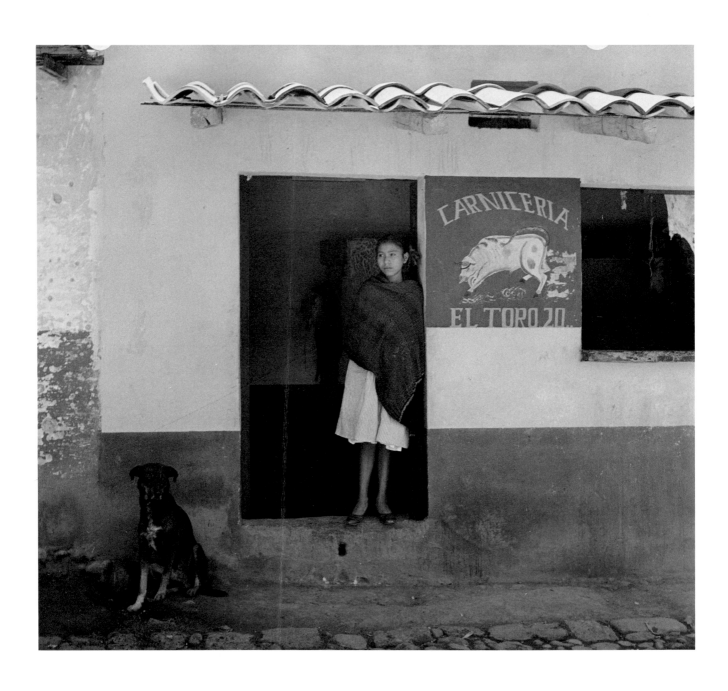

70
El perro veinte
Dog twenty

73
El choque
The collision

74
Trabajadores de fuego
Fire workers
(palladium print)

75
Retrato desagradable
Unpleasant portrait
(palladium print)

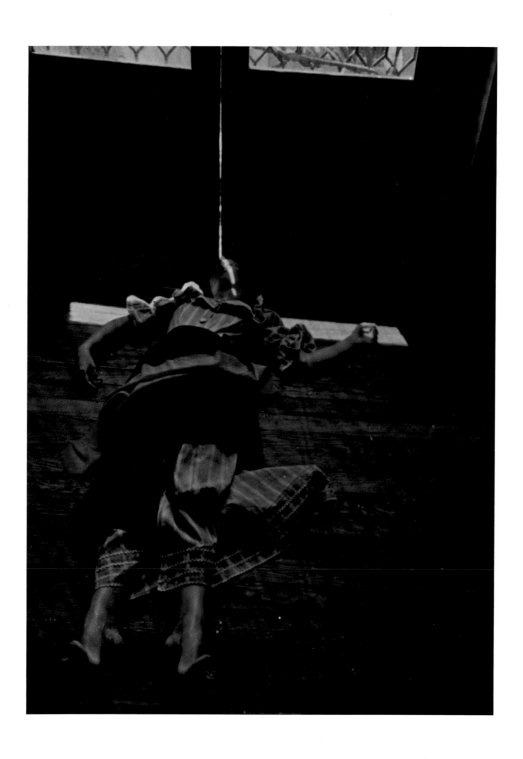

76
En la mañana
In the morning

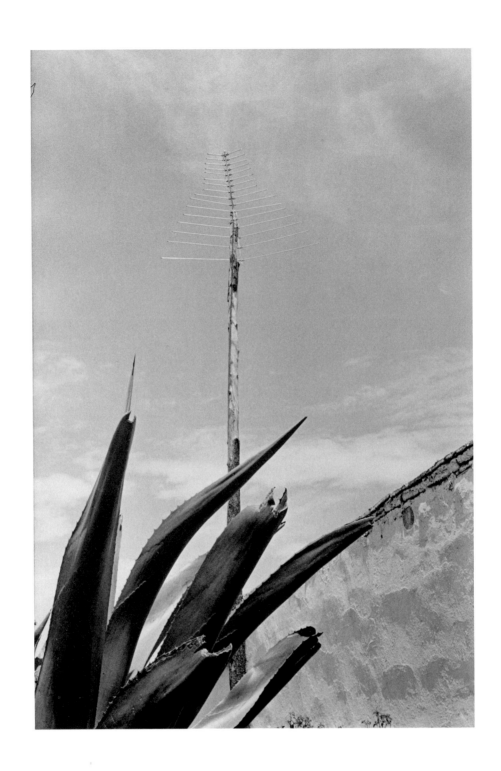

77
Maguey y televisión
Agave and television

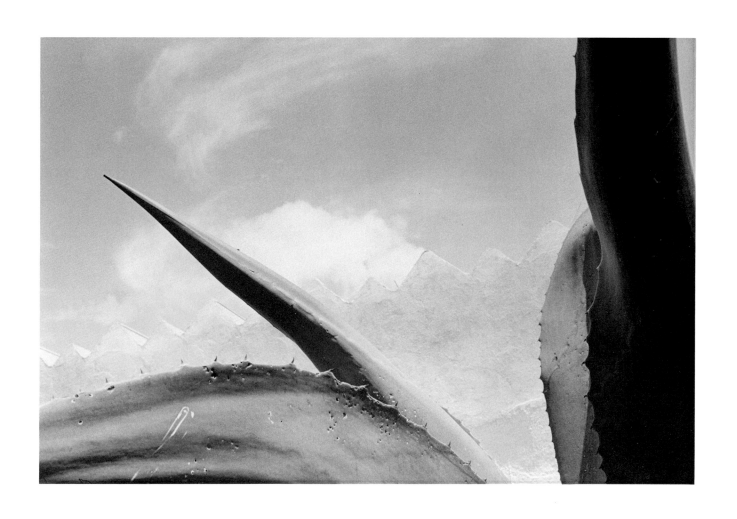

78
Maguey y pared dentada
Agave and serrated wall

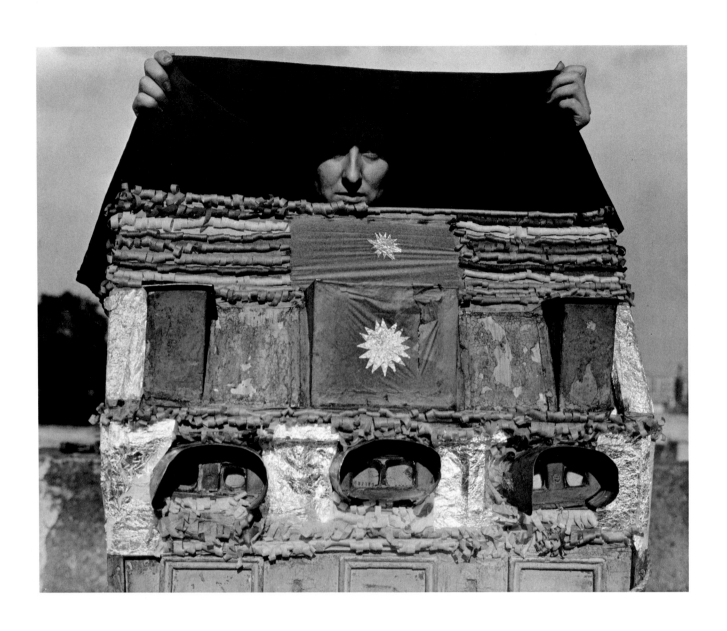

79
Caja de visiones
Box of visions

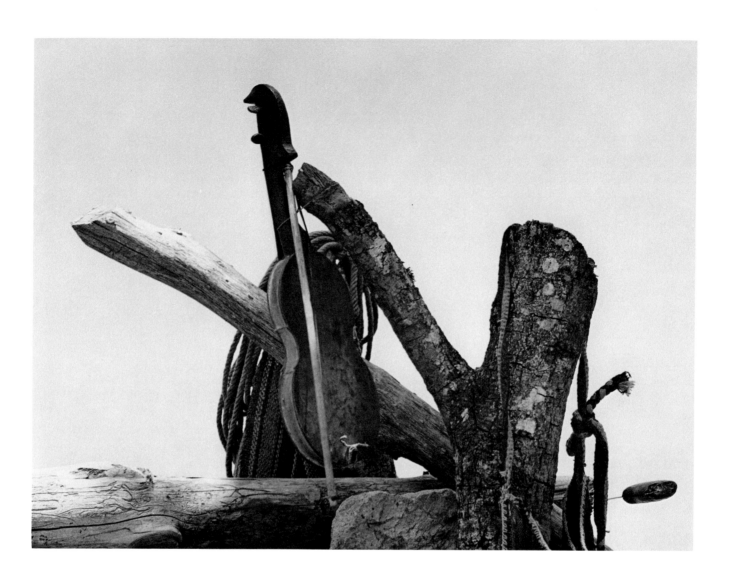

80
Violín huichol
Huichol violin

81
El color
Color

82
Paisaje – San Blas, Nayarit
Landscape – San Blas, Nayarit
(palladium print)

CATALOGUE OF THE EXHIBITION

All photographs are lent by the artist unless otherwise indicated. Dimensions are in inches and centimeters, height preceding width.

1. *Paisaje Chamula con dos grupos* 1972
 Chamula landscape with two groups
 $7\frac{1}{8} \times 9\frac{1}{2}$ 18.1 × 24.1

2. *Que chiquito es el mundo* 1942
 How small the world is
 $7\frac{3}{4} \times 9\frac{7}{8}$ 19.7 × 25.1

3. *Enterramiento en Metepec* 1932
 Burial in Metepec
 $6\frac{7}{8} \times 9\frac{3}{4}$ 17.3 × 24.7

4. *Bicicletas en domingo* 1968
 Bicycles on Sunday
 $7\frac{3}{8} \times 9\frac{5}{8}$ 18.7 × 24.4

5. *Trabajadores del trópico* 1943–44
 Workers of the tropics
 $6\frac{7}{8} \times 9\frac{3}{8}$ 17.3 × 24

6. *Señor de Papantla* 1934–35
 Man from Papantla
 $15\frac{1}{2} \times 11$ 39.4 × 28

7. *La abuela, nuestra abuela* 1940
 The grandmother, our grandmother
 $7\frac{1}{2} \times 9\frac{3}{8}$ 19.2 × 23.9

8. *Arena y ramas* 1920s
 Sand and branches
 $6\frac{7}{8} \times 9\frac{1}{2}$ 17.5 × 24.3

9. *Roca cubierta de liquen* 1927
 Rock covered with lichen
 $8\frac{5}{8} \times 11\frac{3}{4}$ 21.9 × 30

10. *Niño orinando* 1927
 Boy urinating
 $9\frac{1}{2} \times 7\frac{1}{4}$ 24.2 × 18.3

11. *Escala de escalas* 1931
 Ladder of ladders
 $9\frac{5}{8} \times 7\frac{1}{4}$ 24.5 × 18.4

12. *Juego de papel (3)* 1926–27
 Paper game (3)
 $8\frac{1}{8} \times 8\frac{5}{8}$ 20.7 × 22

13. *Juego de papel (2)* 1926–27
 Paper game (2)
 $7\frac{3}{8} \times 9\frac{1}{4}$ 18.8 × 23.6

14. *Paisaje cáctico* 1966
 Cactus landscape
 $10\frac{1}{8} \times 13\frac{1}{2}$ 25.7 × 34.3

15. *Paisaje de siembras* 1972–74
 Landscape of sown fields
 $7\frac{1}{4} \times 9\frac{1}{2}$ 18.5 × 24.3
 Lent by Raymond W. Merritt

16. *Elefante al cielo* 1931
 Elephant in the sky
 $6\frac{3}{4} \times 9\frac{1}{8}$ 17.3 × 23.3

17. *Votos* 1969
 Votive offerings
 $7\frac{3}{8} \times 9\frac{5}{8}$ 18.6 × 24.4

18. *Los obstáculos* 1929
 The obstacles
 $8\frac{1}{2} \times 11\frac{3}{8}$ 21.7 × 28.8

19. *Los venaditos* c. 1930
 The little deer
 (palladium print)
 $7\frac{1}{2} \times 9\frac{1}{2}$ 19 × 24

20. *Donde está la estrella* 1952
 Where the star is
 $9\frac{3}{4} \times 6\frac{3}{4}$ 24.9 × 17.1

21. *Luz restirada* 1944
 Lengthened light
 $9\frac{1}{2} \times 6\frac{1}{2}$ 24.2 × 16.6

22. *Señor Presidente Municipal* 1947
 Mr. Municipal President
 $7\frac{1}{2} \times 9\frac{3}{8}$ 19 × 23.9

180. *Cuatro arbolitos y adobes*　　　1930
Four little trees and bricks
$7\frac{5}{8} \times 9\frac{7}{8}$　　　19.2 × 25

181. *Plátano, planta (plateado)*　　　1974
Plantain, plant (silvered)
$9\frac{5}{8} \times 7\frac{3}{8}$　　　24.4 × 18.8

182. *Las lavanderas sobreentendidas*　　　1932
The washerwomen implied
$9\frac{3}{4} \times 6\frac{7}{8}$　　　24.8 × 17.5

183. *Parábola óptica*　　　1931
Optic parable
$9\frac{3}{4} \times 7\frac{3}{8}$　　　24.8 × 18.7

184. *Mujer con paraguas*　　　1973
Woman with umbrella
(palladium print)
$3\frac{3}{4} \times 4\frac{3}{4}$　　　9.4 × 12

185. *Reyes de danza*　　　c. 1931
Kings of the dance
(palladium print)
$9\frac{3}{8} \times 7\frac{3}{8}$　　　23.8 × 18.8

BIOGRAPHICAL NOTES

This chronology incorporates the material compiled by Fred Parker in the catalogue of the Alvarez Bravo exhibition held at the Pasadena Art Museum in 1971. Unless otherwise noted, indented quotations are taken from the interview with Alvarez Bravo by Paul Hill and Tom Cooper published in *Camera*, May and August 1977, and soon to be published in the book *Dialogue with Photography*, Farrar, Straus & Giroux, Inc.

1902 Born February 4, Mexico City. Because of his grandfather, Manuel Alvarez Rivas, painter and photographer, and his father, Manuel Alvarez García, painter, writer, and amateur photographer, Manuel Alvarez Bravo lived in an "atmosphere in which art was breathed..." and, from his child-hood on, he has felt affection for all the branches of art "which are manifestations for the pleasure and elevation of man: literature, music, painting."

1908–1914 Attended Catholic Brothers' school in Tlalpan, near Mexico City. Learned to read, write, and count, but very little else. Street battles of the 1910 Revolution often interrupted class activities. Sight of cadavers and sound of cannons remain strongest remembrances of this period.

> ...I was also interested in the ceremony of November 12—*The Ceremony of the Dead*, which is also a celebration. On this occasion they used to sell children toys representing death—skulls made of sugar which we children used to eat. I think this is where the real feeling of Mexican duality comes from. The duality of life and death.

1915 Undertook studies in accounting at night while working as a copy-clerk during the day for a French company in Mexico City.

> Those days were very difficult, and it was important to study something profitable—something that would economically help the family.

1916 Began working for the Mexican Treasury Department as an office boy under Venustiano Carranza, who was later President.
Read Rousseau's *Confessions*.

1917 Dropped study of accounting and began attending literature classes at night.

1918 Attended, at night, the Academia Nacional de Bellas Artes (Academia de San Carlos) for one year and studied painting and music.

1922 Began developing interest in photography and indigenous Mexican art while working for the Power and Transportation Department. Because of his employer, Hugo Conway, subscribed to the English publication *Amateur Photographer and Photography*.

1923 Met the German photographer Hugo Brehme.

1924 Purchased his first camera—Century Master 25. With initial advice from Brehme and with ad-ditional subscriptions to *Camera*, *Camera Craft*, and *American Photography* began his photographic career.

1925 Married Dolores (Lola) Martínez Vianda. Accepted a post with the Treasury Department in Oaxaca and left Mexico City.

1926 Received first prize in Regional Exhibition in Oaxaca.

1927 Returned to Mexico City.

1927–1931 Worked as a typist for the Department of Agriculture and the Treasury Department in Mexico City.

1927 Introduced to Tina Modotti by muralist Paul O'Higgins.

> One day a friend pointed out two people, Tina and Weston; each was carrying a camera. That was the first time I saw her, near La Santísima Church. They looked at the church but didn't take any pictures. That was my first glimpse of Tina. . . .
>
> . . . I met her for the first time in 1927. I was in Oaxaca where I worked during the years 1925–26. While in Oaxaca I received many magazines and other publications from Mexico City, and through them I learned about Tina Modotti, particularly through two magazines—one published by Gabriel Figueroa and Gabriel Fernández Ledesma, who was also her friend, and Frances Toor's magazine, *Mexican Folkways*. I had been working in photography since 1924 and was very eager to meet her.
>
> . . . I visited her on many occasions, and she was generally very busy—meetings with people like Carleton Beals and Frances Toor, but they were speaking English, and I don't know how to speak English. But very often on a visit she would show me what she had done and what Weston was sending her, and we would talk for a long while. . . . (Mildred Constantine, *Tina Modotti: A Fragile Life*, pp. 112–113.)

(Alvarez Bravo later stated that he got Modotti's address and telephone number through one of the magazines and called her himself.)

1929 Introduced by Tina Modotti to Diego Rivera and to Frances Toor, writer and editor of *Mexican Folkways*. At Tina's suggestion, Alvarez Bravo sent a portfolio of prints to Edward Weston, who responded in a letter:

> Pardon me but I am not sure whether I am addressing ¿Señor, Señora or Señorita?
>
> I am wondering why I have been the recipient of a very fine series of photographs from you? . . .
>
> But no matter why I have them, I must tell you how much I am enjoying them. Sincerely, they are important—and if you are a new worker, photography is fortunate in having someone with your viewpoint. It is not often I am stimulated to enthusiasm over a group of photographs.
>
> Perhaps the finest, for me, is the child urinating: finely seen and executed. Others I especially like are: the pineapple, the cactus, the lichen covered rock, the construction, the skull. . . . (Letter in the archives of The Pasadena Art Museum, Pasadena, California.)

1929–1930 Taught photography for one year at the Escuela Central de Artes Plásticas (Academia de San Carlos) while Diego Rivera was director and left with Rivera's staff when the latter resigned over a curriculum dispute.

1930 Tina Modotti deported from Mexico. Alvarez Bravo helped her pack and was the only person to see her to her train. On Tina's departure he took her job as photographer of art for *Mexican Folkways* magazine; she left with him her 8×10 view camera, with which he made a number of important works. Frances Toor introduced Alvarez Bravo to most of Mexico's muralists and artists (Rufino Tamayo, Dr. Atl, David Alfaro Siqueiros, José Clemente Orozco, Frida Kahlo de Rivera, Jean Charlot, Fernando Gamboa, Xavier Villaurrutia, Francisco Miguel) and commissioned photography of their work for publication. Met Emily Edwards and began assisting her (with Paul O'Higgins) in gathering material for *Painted Walls of Mexico*, published in 1966.

> Q. How did . . . painters like Diego Rivera, Orozco, and Siqueiros react to your work?
> A. Very positively. But I also had direct criticism, especially from Diego Rivera. When he was criticizing my work, or a young painter's work, he criticized the substance of the work, rather than the sentiments behind it. . . .
> Q. This was the early thirties and a very political time in Mexico? Did you get involved?
> A. The whole intellectual world was left-wing but I never joined the Party. I did belong to a league which was called LEAR, which stood for the Revolutionary League of Writers and Artists. But at the same time I was friends with some artists who were not left-wing oriented. I always believed that talent and sensibility had nothing to do with politics.

1930–1931 Worked as a cameraman on Sergei Eisenstein's film *Que Viva México*.

1931 Received First Prize in competition sponsored by La Tolteca, a cement manufacturer. On the verge of advancement in the Treasury Department, decided to leave business to become a free-lance photographer, specializing in the reproduction of painting and other art work.

1932 First one-man exhibition, Galería Posada, Mexico City.

1932–1933 Taught photography a second time at the Escuela Central de Artes Plásticas (Academia de San Carlos). Also worked for the Education Department as photographer of art.

1933 Introduced to Paul Strand in Mexico.
> Q. Did Strand interest you in film?
> A. Yes. I knew his film *The Wave* [made in 1933]. Interestingly, while Strand was working on his film by the river in Vera Cruz, I produced the photograph of the *Assassinated Worker* quite nearby.

1934 Made *Tehuantepec*, "a picturesque film which ends in tragedy," based on a labor strike.
Introduced to Henri Cartier-Bresson in Mexico in the course of planning a touring exhibition (with Cartier-Bresson) which opened at The Julien Levy Gallery in New York and came to Mexico in 1935.

Q. How was your 1935 exhibition with Cartier-Bresson received?

A. Photography was not very popular in Mexico. People were interested in painters and writers but not photographers. The only thing I can say is that there was a great interest in Cartier-Bresson's work.

1936 Traveled to Chicago to teach for two or three months at Hull-House Art School, directed by Emily Edwards.

1938 Introduced to André Breton in Mexico. Became exposed to the surrealist movement and was impressed by Buñuel's film *Un Chien Andalou*.

Breton was living in Diego Rivera's house, and it was at Diego's that we met.

Q. What did he say about your photographs?

A. He liked them very much.

Q. Did he feel there was a surrealistic element in them?

A. I don't think so. Breton had a great ability to recognize the authentic. He would, for example, immediately notice a painter who falsely tried to be surrealistic. Art for him, if not surrealist, had to have dimensions of the fantastic.

Q. What was the main thing that Breton saw in your work?

A. Probably the relationship of the photographic values with the content. But he also talked about photographic quality and photographic realization. He was, however, most impressed by the content.

Q. Did Surrealism have an effect on you then?

A. Probably not. I knew about it, though not thoroughly, through some French magazines; and I might have produced some work under its influence. . . .

A certain amount of sober speculation with respect to hidden symbolism has taken place with respect to the photograph *Good reputation sleeping*. In fact, it was made as kind of a joke. In response to an invitation from André Breton to participate in a surrealist exhibition held in Mexico City in 1938 the photographer and a student went out onto the roof of the Academia de San Carlos, where he then taught, and contrived to invent a picture which would look suitably "surreal." Actually several posed studies of a bandaged nude were taken on this occasion. The artist now recounts this anecdote with undisguised amusement. (Jane Livingston, conversation with the artist. Coyoacán, Mexico City, June 1976.)

The bandages most certainly originate from a visual experience. I found the relationship very recently. I used to attend the rehearsals of the Anna Sokolof group, and the girls used to bandage their feet for the rehearsals. . . . it might be possible that it deals with sacrifice. Since people have been insisting on reading and interpreting my photographs and establishing things that influenced my work, I thought about it myself, and I came to the conclusion that Rousseau's *Bohemia* had a great influence on me.

1939–1942 Maintained commercial photographic shop on Ayuntamiento Street, Mexico City.

1941 Tina Modotti returned to Mexico but was no longer photographing.

1942 Married second wife, Doris Heydn (writer, archeologist, and, later, photographer). Through a gift by Edgar Kaufman, who had bought the works from the artist in Mexico, The Museum of Modern Art in New York acquired a group of his photographs.

1943–1959 Regularly employed as photographer and cameraman at the Sindicato de Trabajadores de la Producción Cinematográfica de México.

> Q. Did you exhibit much?
> A. For 16 years I did very little personal work and had only one exhibition
> in 1957 at The National Institute of Art.

1947–1950 Taught photography at the Instituto Cinematográfico Mexicano, Escuela de Artes Plásticas, and the Centro Universitario de Estudios Cinematográficos.

> I taught it as a creative medium, but at that time lots of people were only
> interested in the technical aspects of photography.

1957 Eastman House, Rochester, New York, acquired 45 of his photographs.

1959 Left the cinematographic industry to begin (with Leopoldo Méndez, Gabriel Figueroa [a cousin of former president López Mateos], Carlos Pellicer and others) El Fondo Editorial de la Plástica Mexicana (editorial fund or foundation of Mexican plastic arts) which publishes very fine books on Mexican art. Manuel Alvarez Bravo presently continues to serve as the chief photographer and as one of the directors.

Books published by this organization:

Mural Painting of the Mexican Revolution, 1960
Los Maestros Europeos en las Galerías de San Carlos, de México, 1962
José Guadalupe Posada, Ilustrador de la Vida Mexicana, 1963
Flor y Canto del Arte Prehispánico de México, 1964
José Maria Velasco, 1970
Lo Efímero y Eterno en el Arte Popular Mexicano, 1971
Juan Gerson, Pintor Indigenadil Siglo XVI, Tecamachalco, Pueblo, 1972
Joaquín Clausell, 1973
Dr. Atl, 1975

> . . . to be a member of the technical committee [of the Fondo Editorial de la Plástica Mexicana] meant making photographs and spreading Mexican Art around the country and abroad.

1960 Traveled to Europe, visited many museums while working for El Fondo Editorial de la Plástica Mexicana. Remained in Europe for entire year.

1961 Returned to Europe for three-month period. Visit to Cathedral of Sforza in Milan initiated a continuing interest in architecture, particularly that of the Mexican Baroque.

1962 Divorced Doris Heydn.
Returned to Europe for three-week period.
Married third wife, Colette Urbajtel.

1966	Met with Paul Strand a second time in Mexico.
1971	Pasadena Art Museum, Pasadena, California, acquired 63 photographs.
1972	Donated to The Museum of Modern Art, Mexico City, his collection of early photographs, toward the foundation of a permanent photographic collection.
1974	Received Sourasky Prize from secretary of Public Education, Mexico.
1975	Portfolio of 15 photographs edited by Lee Friedlander published by Double Elephant Press, New York City, with reprint of 1939 statement by Breton. Awarded Premio Nacional de las Artes by Mexican government.
1976	Museum of Modern Art, Mexico City, opens a room permanently dedicated to Alvarez Bravo. Received John Simon Guggenheim Fellowship.
1977	Portfolio of 15 photographs issued by Acorn Press, New York City.
1978	Visited Europe in summer. Lives and works in Mexico City.

EXHIBITIONS, CATALOGUES, REVIEWS

1926 Oaxaca, Mexico. Regional exhibition, received first prize for photography.

1929 Galería de Arte Moderno del Teatro Nacional, Mexico City. Group exhibition.

Francisco, Miguel. "Un fotógrafo mexicano—Manuel Alvarez Bravo," *El Universal* (Mexico City), January 5, 1930.

1931 La Tolteca, Mexico City. Received first prize for photography in national painting and photography competition.

1932 Galería Posada, Mexico City. Individual exhibition, July 28 – August 10. Catalogue with text by Xavier Villaurrutia.

1935 Galería de Exposiciones del Palacio de Bellas Artes, Mexico City. Two-man exhibition with Cartier-Bresson, March 11–20. Catalogue with statements by Luis Cardoza y Aragón and Langston Hughes.

Julien Levy Gallery, New York City. Three-man exhibition with Walker Evans and Cartier-Bresson, May.

1936 Hull-House Art School, Chicago, Illinois. Individual exhibition, March 22–31.

Edwards, Emily. "Mexico's Leading Photographer . . . ," *Hull-House Art School News Release*, Chicago, March.

1939 Galerie Renou et Colle, Paris. Survey exhibition of Mexican art organized by André Breton, March. Catalogue with text by Breton.

1940 Galería de Arte Mexicano (Galería de Inés Amor), Mexico City. "Exposición Internacional del Surrealismo," group exhibition, January–February. Catalogue.

The Museum of Modern Art, New York City. "Twenty Centuries of Mexican Art," group exhibition, May. Manuel Alvarez Bravo and Lola Alvarez Bravo only

photographers included in exhibition. Extensive catalogue, one reproduction.

Weinstock, Herbert. *Mexican Music*, New York: Museum of Modern Art, nine reproductions.

1942 Photo League Gallery, New York City. Individual exhibition, January 10 – February 1.

1943 Philadelphia Museum of Art, Philadelphia, Pennsylvania. "Mexican Art Today," group exhibition, March 27 – May 9. Catalogue with text by Luis Cardoza y Aragón.

Art Institute of Chicago, Illinois. Individual exhibition, December 10 – January 16, 1944.

1945 Sociedad de Arte Moderno, Mexico City. "Manuel Alvarez Bravo—Fotografías," individual exhibition, July. Extensive catalogue, 30 reproductions; 115 of the edition of 1000 were signed and numbered and contained three original photographs. Essays by Manuel Alvarez Bravo, Diego Rivera, Xavier Villaurrutia, and Gabriel Figueroa.

The Museum of Modern Art, Moscow, Russia. Group exhibition for cultural exchange program.

1947 Israel. Group exhibition for cultural exchange program tour.

1954 Sindicato de Trabajadores de la Producción Cinematográfica de México, Mexico City. Received first prize and honorable mention in photography competition sponsored by this organization.

Centro de Relaciones Culturales Anglo-Mexicano, Mexico City. Two-man exhibition (other photographer unknown), October 3–13.

1955 The Museum of Modern Art, New York City. "The Family of Man," group exhibition, organized by Edward Steichen, January 24 – May 8, circulated through 1959. Extensive catalogue edited by Edward Steichen, published by Maco Magazine Corporation, New York City, 1955, two reproductions.

1956 The Museum of Modern Art, New York City. "Diogenes with a Camera III," four-man exhibition with Paul Strand, August Sander, and Walker Evans, January 17 – March 18. The Museum of Modern Art, New York City, news release #5, January 18, 1956, with statements by Edward Steichen and Alvarez Bravo.

Deschin, Jacob. "Diogenes III at Museum," *The New York Times*, January 22, Sect. II, p. x19.

1957 Salón de la Plástica Mexicana, Instituto Nacional de Bellas Artes, Mexico City. Individual exhibition, March 7–26. Brochure with statement by Diego Rivera.

1959 George Eastman House, Rochester, New York. "Photography at Mid-Century," group exhibition organized by Beaumont Newhall, November–December, circulated through 1961. Catalogue edited and with text by Beaumont Newhall, one reproduction.

1961 Bibliothèque Nationale, Paris. "Salon International du Portrait Photographique," group exhibition.

1962 L'Œil Galerie d'Art, Paris. "Minotaure," group exhibition with photographs by Alvarez Bravo brought back from Mexico in 1939 by André Breton, May-June. Catalogue edited by Jean-François Revel.

1964 The Museum of Modern Art, New York City. "The Photographer's Eye," group exhibition, May–September, circulated through 1971. Book edited and with text by John Szarkowski published in 1966, one reproduction.

1966 Galería de Arte Mexicano (Galería de Inés Amor), Mexico City. Individual exhibition, May 9–28. Catalogue, one reproduction.

1967 National Gallery of Canada, Ottawa. "Photography in the Twentieth Century," group exhibition organized by George Eastman House, Rochester, New York, February 16 – April 12, circulated through 1971. Catalogue edited and with text by Nathan Lyons published by Horizon Press.

1968 Palacio de Bellas Artes, Mexico City. "Manuel Alvarez Bravo—Fotografías 1928–1968," individual exhibition, June 25 – August 10. Two catalogues issued by the Comité Organizador de los Juegos de la XIX Olimpiada; one in English, Spanish, and French with essay by Juan García Ponce and 86 reproductions, the second in Spanish with essay by Luis Cardoza y Aragón and 12 reproductions.

Programa Cultural de la XIX Olimpiada. *Guía de Exposiciones Agosto*, Mexico City: Comité Organizador de los Juegos de la XIX Olimpiada, pp. 76–83, illus.

1971 Pasadena Art Museum, Pasadena, California. Individual exhibition organized by Fred Parker, May 4 – June 20. Extensive catalogue with essay, detailed chronology, and bibliography by Fred Parker, 33 reproductions. Exhibition traveled to: Museum of Modern Art, New York City, July 7 – August 25, 1971; George Eastman House, Rochester, New York, September 6 – October 15, 1971; Humboldt State College, Arcata, California, May 1 – June 15, 1972; Santa Barbara Museum of Art, Santa Barbara, California, August 4 – September 29, 1972; Phoenix Art Museum, Phoenix, Arizona, November 3 – December 17, 1972; Friends of Photography, Carmel, California, January 2 – 28, 1973; School of Architecture and Planning, Massachusetts Institute of Technology, Cambridge, Massachusetts, February 27 – March 12, 1973; Milwaukee Art Center, Milwaukee, Wisconsin, March 23 – April 22, 1973; San Francisco Museum of Art, San Francisco, California, June 4 – July 22, 1973.

Coleman, A. D. "Photography: Death in Many Forms," *The New York Times*, July 18, 1975, Sect. 2, p. 14, ill.

Cordoni, David. "Manuel Alvarez Bravo," *Artweek*, vol. 4, no. 24, July 7, 1973, pp. 9–10, illus.

"Exhibition by Mexico's Greatest Lenser Opens at Art Museum," *Star-News* (Pasadena, California), May 5, 1971, p. B-1.

Greenberg, Jane. "Gallery Snooping," *Modern Photography*, vol. 35, no. 11, November 1971, p. 60, ill.

Kelly, Jain. "Shows We've Seen," *Popular Photography*, vol. 69, no. 5, November 1971, p. 26.

Littlewood, John. "Bravo's Mexican Pictures: Photographic Timelessness," *The Christian Science Monitor*, April 5, 1973, p. 22, ill.

Rice, Leland. "Mexico's Master Photographer," *Artweek*, vol. 2, no. 20, May 22, 1971, illus.

Wilson, William. "Unmasked as Art: Two Photo Shows at PAM," *Los Angeles Times*, May 10, 1971, Part IV, p. 5.

1972 Witkin Gallery, New York City. Individual exhibition, July 26 – August 27.

Case, William D. "In the Galleries," *Arts*, vol. 47, no. 1, September/October, p. 62.

Instituto Nacional de Bellas Artes, Palacio de Bellas Artes, Mexico City. "Manuel Alvarez Bravo; 400 fotografías," July–September. Catalogue with essay by Jorge Hernández Campos, 17 reproductions.

Hayden Gallery, Massachusetts Institute of Technology, Cambridge, Massachusetts. "Octave of Prayer," group exhibition organized by Minor White, November. Catalogue edited and with essay by Minor White published by Aperture, Inc., one reproduction.

1973 Casa de la Cultura, Juchitán, Mexico. Individual exhibition of photographs acquired by Francisco Toledo for the Casa de la Cultura, also exhibited in Oaxaca.

1974 Galería José Clemente Orozco, Mexico City. "Cien fotografías y paisajes inventados," individual exhibition.

Salón de Fotografía, Casa del Lago, Mexico. Individual exhibition.

Galería Arvil, Mexico City. "Retratos de los treintas y Cuarentas," Individual exhibition.

Museo de Ciencias y Arte UNAM, Mexico City. "La Muerte; expresiones mexicanas de un enigma," group exhibition. Catalogue.

Art Institute of Chicago, Illinois. Individual exhibition of photographs from the collection of the Instituto Nacional de Bellas Artes, Mexico City, April 6 – June 2.

Lindley, Dan. "Bravo's Photos: What's Happening Here?" *Chicago Campus Circle*, April 22.

Pare, Richard. "Manuel Alvarez Bravo—Hieratic Images of Life and Death," *New Art Examiner* (Chicago), vol. 1, no. 7, April, p. 9.

University of Massachusetts Art Gallery, Boston. Individual exhibition selected by Alvarez Bravo, October.

Wagner, Anne Middleton. "Manuel Alvarez Bravo and Roy DeCarava at the University of Massachusetts Art Gallery," *Art in America*, vol. 63, no. 3, May/June 1975, pp. 77–78, ill.

1975 Museum of Modern Art, Caracas, Venezuela. individual exhibition.

Witkin Gallery, New York City. Individual exhibition, May–June 1975.

"Goings on about Town: Photography," *The New Yorker*, vol. 51, no. 15, June 2, p. 10.

André, Michael. "Photography: Manuel Bravo (Witkin)," *Art News*, vol. 74, no. 7, September, p. 104.

Thornton, Gene. "The Mexico of Alvarez Bravo," *The New York Times*, May 25, Sect. 2, p. 25, ill.

Galería Juan Martín, Mexico City. Individual exhibition, March 10 – July 19.

Elizondo, Salvador. "Manuel Alvarez Bravo," *Plural* (Mexico City), vol. 4, no. 11, August, pp. 77–78, illus. pp. 5, 78.

Pan Opticon Gallery, Boston. Individual exhibition, October 10–30.

1976 La Photogalerie, Paris. Individual exhibition, April–July. Pamphlet with text by Denis Roche, 16 reproductions.

Nurisdany, Michel. "Le Mexique sans folklore d'Alvarez Bravo," *Le Figaro* (Paris), April 26.

Voyeux, Martine. "Voir, c'est un vice," *Le Quotidien de Paris* (Paris), May 13.

Photographers Gallery, London. Group exhibition, April–July.

Jeffrey, I. "Photography: Photographers Gallery, London," *Studio International*, vol. 192, no. 990, pp. 75–77, ill.

Museé Nicéphore Nièpce, Chalon-sur-Saone, France. Individual exhibition.

Galería Il Diaframma, Milan, Italy. Individual exhibition.

1977 Galería Juan Martín, Mexico City. Individual exhibition, June–July. Brochure with text by Carlos Monsivais, four reproductions.

1978 Nova Gallery, Vancouver, British Columbia, Canada. Individual exhibition, March.

Whitehead, Janice. "Noticeboard," *Vanguard* (Vancouver), vol. 7, no. 2, March, p. 21, ill.

Kiva Gallery, Boston. Individual exhibition, March 15 – April 15.

Alonso, Jessica. "From the Soul of Mexico to the Heart of America," *The Boston Globe*, March 29.

Cohen, Stu. "Photography: Shooting the Heart of Mexico," *The Boston Phoenix*, April 4, 1978, Sect. 3, p. 9.

San Francisco Art Institute, San Francisco, California. Individual exhibition, April 28 – May 17.

Frankenstein, Alfred. "Fantastic Invention of a Watercolorist," *San Francisco Chronicle*, May 13.

Murray, Joan. "Manuel Alvarez Bravo: 'Como Siempre'," *Artweek*, vol. 9, no. 19, May 13, pp. 1, 11, illus.

"San Francisco Highlights: San Francisco Art Institute," *West Art*, April 28.

GENERAL BIBLIOGRAPHY

1930 Brétal, Máximo. [Untitled statement about Alvarez Bravo], *Excelsior* (Mexico City), November 13.

1932 Edwards, Emily. *The Frescoes of Diego Rivera in Cuernavaca*, Mexico City: Editorial "Cvltvra." Photographs by Alvarez Bravo.

1938 Maldonado, Eugenio. "The Indian Problem," *Mexican Art and Life* (Mexico City), October, ill.

1939 Breton, André. "Souvenir du Mexique," *Minotaure* (Paris), ser. 3, no. 12–13, May, pp. 29–52, illus.
Cardoza y Aragón, Luis. "Light and Shadow," *Mexican Art and Life* (Mexico City), no. 6, April.
Péret, Benjamin. "Ruines: Ruine des Ruines," *Minotaure* (Paris), ser. 3, no. 12–13, May, ill. p. 57.
Villaurrutia, Xavier. "Manuel Alvarez Bravo," *Artes Plásticas* (Mexico City), no. 1, Spring.

1941 Helm, MacKinley. *Modern Mexican Painters*, New York: Harper & Brothers.

c. 1942 Alvarez Bravo, Manuel. *Tina Modotti*, Mexico City: Galería de Arte Mexicana (Galería de Inés Amor). Memorial exhibition brochure.

1942–1944 Paalen, Wolfgang (ed.). *Dyn* (Mexico City), miscellaneous illus.: vol. 1, no. 2, July–August 1942, p. 18; vol. 1, no. 3, Fall 1942, p. 35; vol. 1, no. 4–5, December 1943, pp. 17 and 26; vol. 1, no. 6, November 1944, p. 40.

1943 *Los tesoros del Museo Nacional del México*, Mexico City: Editorial "Cvltvra." Photographs by Alvarez Bravo.

1945 Siqueiros, David Alfaro. "Movimiento y 'Meneos' del arte en México," *ASI* (Mexico City), August 18.

1953 Villaurrutia, Xavier. *Obras*, Mexico City: Fondo de Cultura Económica, p. 1056.
White, Minor. "Manuel Alvarez Bravo," *Aperture*, vol. 1, no. 4, pp. 28–36, illus.

1961 Weston, Edward (Nancy Newhall, ed.). *The Daybooks of Edward Weston*, New York: Horizon Press, vol. 2, p. 119.

1964 Rothenstein, Sir John. *The World of Camera*, London: Thomas Nelson and Sons, Ltd.

1966 Edwards, Emily. *Painted Walls of Mexico*, Austin: University of Texas Press. Photographs by Alvarez Bravo.
Nelken, Margarita. "Manuel Alvarez Bravo," *Excelsior* (Mexico City), June 3.
Szarkowski, John. *The Photographer's Eye*, New York: Museum of Modern Art, p. 151, ill.

1968 Aperture, Inc. "Manuel Alvarez Bravo—Portfolio of Mexican Photographs, with a Statement by Paul Strand," *Aperture*, vol. 13, no. 4, p. 2, illus. pp. 3–9.
Gasser, Manuel. "1929–1939: A Decade and Its Photographers," *Du* (Zurich), 28th year, July.

1969 Prampolini, Ida Rodríguez. *El surrealismo y el arte fantástico de México*, Mexico City: Universidad Nacional Autónoma de México, Instituto de Investigaciones Estéticas, pp. 59–60, illus.

1970 *Códices Tuxpán. Los lienzos de Tuxpán*, Mexico City: Editorial la Estampa Mexicana. Photographs by Alvarez Bravo.
Crespo de la Serna, Jorge. "Perfiles de México #43—Manuel Alvarez Bravo," *El Dia* (Mexico City), April 4.
Grace, Robin. "Manuel Alvarez Bravo," *Album* (London), vol. 9, October, pp. 2–14.

1972 Parker, Fred R. "Manuel Alvarez Bravo," *Camera*, vol. 51, January, pp. 34–43, illus.

1973 Editors of Time-Life Books. *Great Photographers*, New York: Time-Life International, p. 143, illus. pp. 178–179 (The Life Library of Photography).
Szarkowski, John. *Looking at Photographs: 100 Pictures from the Collection of the Museum of Modern Art*, New York: Museum of Modern Art, p. 132, ill. p. 133.

1974 Taracena, Berta. "Nuevo Sentido de la Visión," *Revista México en la cultura. El Nacional* (Mexico City), June 2.

1975 "El arte fotográfico de Manuel Alvarez Bravo," *Revista de Bellas Artes* (Mexico City), January/February.

Beaton, Cecil, and Gail Buckland. *The Magic Image: The Genius of Photography from 1839 to the Present Day*, London: Weidenfeld and Nicolson, p. 167, ill.

Constantine, Mildred. *Tina Modotti: A Fragile Life*, New York: Paddington Press, Ltd., pp. 15, 112, 113, 169, 214.

"Photography—a Contemporary Compendium: Biographies," *Camera*, vol. 54, no. 11, November, p. 14, ill.

Turner, Peter. "Manuel Alvarez Bravo" in Colin Osman and Peter Turner (eds.), *Creative Camera International Yearbook*, London: Coo Press, pp. 10–36, illus.

1976 Badger, Gerry. "The Labyrinth of Solitude; The Art of Manuel Alvarez Bravo," *The British Journal of Photography*, vol. 123, no. 6043, May 21, pp. 425–428, illus. and cover.

Coleman, A. D. "The Indigenous Vision of Manuel Alvarez Bravo," *Artforum*, vol. 14, no. 8, April, pp. 60–63, illus.

"Collections," Everson Museum of Art Bulletin, June, p. 1, ill. cover.

García, Emma Cecilia. "Una posible silueta para una futura historiografía de la fotografía en México," *Artes Visuales* (Mexico City), vol. 12, October/December, pp. 2–6, English translation pp. 33–34.

Gutiérrez-Moyano, Beatriz. "¿Qué pasa con la fotografía mexicana de hoy?", *Artes Visuales* (Mexico City), vol. 12, October/December, pp. 19–23, English translation pp. 38–40.

"Manuel Alvarez Bravo," *Artes Visuales* (Mexico City), vol. 12, October/December, pp. 16–18, illus.

"Manuel Alvarez Bravo," *Plural* (Mexico City), no. 58, July, p. 46.

Paz, Octavio. "Cara al tiempo," *Plural* (Mexico City), no. 58, July, pp. 43–45. Poem for Alvarez Bravo, illus.

1977 Garcia Canclini, Nestor. "La fotografía, estética de lo cotidiano," *Artes Visuales* (Mexico City), vol. 14, Summer, p. 19, ill.

Hill, Paul, and Tom Cooper. "Manuel Alvarez Bravo," *Camera*, vol. 56, no. 5, May, pp. 36–38; vol. 56, no. 8, August, pp. 35–36. Interview with Alvarez Bravo in two parts.

THE CORCORAN GALLERY OF ART

TRUSTEES

Mrs. Albert Abramson
Mrs. Melvin Alper
Mrs. Philip Amram
Mr. Smith Bagley
Mrs. Bernhard G. Bechhoefer, *ex officio*
Mr. James Biddle
Mr. Niles W. Bond, *Secretary*
Mr. Chester Carter
Mrs. Robert Dudley, *ex officio*
The Honorable William H. G. FitzGerald
Mr. Lee M. Folger, *Treasurer*
Mr. Carl M. Freeman
Mr. John H. Hall, *2nd Vice President*
Mr. George E. Hamilton, Jr.
Mr. Hadlai A. Hull
Mr. Hugh N. Jacobsen
Mr. Freeborn G. Jewett, Jr., *1st Vice President*
Mr. Gilbert H. Kinney
Mr. David Lloyd Kreeger, *President*
Mrs. John A. Logan
Mrs. Leonard H. Marks
Mr. Charles McKittrick
Ms. Constance Mellon
The Honorable J. William Middendorf, II
Mrs. John U. Nef

Mr. Mandell J. Ourisman
Mr. Maxwell Oxman
Mrs. Donald Petrie
Mr. Michael M. Rea
Mrs. Walter Salant
Mr. B. Francis Saul, II
Mr. Frederic W. Schwartz, Jr.
Mr. Leonard L. Silverstein
Mr. Adolph Slaughter
Mrs. John Lewis Smith
Mr. Carleton B. Swift, Jr.
Mrs. Maurice B. Tobin
Mrs. Wynant D. Vanderpool, Jr.
Mr. Robert L. Walsh, Jr.
Mrs. Brainard H. Warner, III
Mrs. John W. Warner
Mr. J. Burke Wilkinson
Mr. Curtin Winsor, Jr., *Assistant Treasurer*
Mrs. Peter Wood, *ex officio*
The Honorable Stanley Woodward
Mrs. David N. Yerkes

TRUSTEES EMERITI
Frederick M. Bradley
Gordon Gray
Corcoran Thom, Jr.

STAFF

Peter C. Marzio, *Director*
Jane Livingston, *Associate Director*
Edward J. Nygren, *Curator of Collections*
Frances Fralin, *Assistant Curator*
Linda C. Simmons, *Assistant Curator of Collections*
Marti Mayo, *Coordinator of Exhibitions*
Martha Pennigar, *Curatorial Assistant*
Pamela Lawson, *Secretary to the Associate Director*
Sheena Parkinson, *Secretary to the Curator of Collections*
Susan P. Williams, *Registrar*
Shelby White Cave, *Associate Registrar*
Robert Scott Wiles, *Conservator*
Fern Bleckner, *Paper Conservation Assistant*
Anthony Blazys, *Preparator*
James Opinsky, *Assistant Preparator*
Jane Brown, *Administrative Assistant, Education*

Theresa Simmons, *Education Assistant*
Sheila Muccio, *Director for Development*
Francis Harper, *Administrative Officer*
William O. Snead, *Director of Building Projects*
Sally Opstein, *Special Assistant*
Carolyn Campbell, *Public Relations*
David Stainback, *Executive Assistant*
Ann Kerwin, *Administrative Assistant*
Susan Gates, *Executive Secretary*
Ann-Caroline Lindgren, *Development Secretary*
Robert Stiegler, *Comptroller*
Alfred Heinman, *Bookkeeper*
Ellen Wright, *Corcoran Shop Manager*
Sharon Caldwell, *Corcoran Shop Assistant*
Howard J. Osborne, *Security Officer*
Einar Gomo, *Building Superintendent*

Three thousand copies of this book,
of which one thousand are hardbound,
were printed by The Stinehour Press,
Lunenburg, Vermont.
The plates are by The Meriden Gravure Company,
Meriden, Connecticut.

Designed at The Hollow Press,
Washington, D.C.,
by Caroline Orser and Alex Castro.

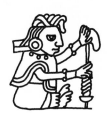